A
BOUNDARY
WATERS
HISTORY

A
BOUNDARY
WATERS
HISTORY

···

CANOEING ACROSS TIME

STEPHEN WILBERS

Introduction by Bill Hansen,
Sawbill Canoe Outfitters

Charleston · London

THE
History
PRESS

Published by The History Press
Charleston, SC 29403
www.historypress.net

Cover image used with permission of Craig Blacklock of Blacklock Photography Galleries.
www.blacklockgallery.com

First published 2011

Manufactured in the United States

ISBN 978.1.59629.970.2

Library of Congress Cataloging-in-Publication Data

Wilbers, Stephen, 1949-
A Boundary Waters history : canoeing across time / Stephen Wilbers.
p. cm.
Includes bibliographical references and index.
ISBN 978-1-59629-970-2
1. Boundary Waters Canoe Area (Minn.)--History. 2. Boundary Waters Canoe Area
(Minn.)--Description and travel. 3. Wilbers, Stephen, 1949---Travel--Minnesota--Boundary
Waters Canoe Area. 4. Canoes and canoeing--Minnesota--Boundary Waters Canoe Area.
5. Natural history--Minnesota--Boundary Waters Canoe Area. 6. Boundary Waters Canoe
Area (Minn.)--Environmental conditions. I. Title.
F612.B73W55 2011
977.6'75--dc23
2011021479

To my dad, Larry Wilbers

With special thanks to Joe Paddock, who never lost faith in my ability to write this book

Enjoy your trip on the…what are the Boundary Waters? Is it that dotted line across Lake Superior?

—A newspaper editor in Texas wishing the author a good trip

CONTENTS

CONTENTS

FOREWORD

This is a love story.

Built on a framework of personal journals, this book is a record of nearly thirty years of canoe trips, taken almost entirely in the Boundary Waters Canoe Area (BWCA) Wilderness in northeastern Minnesota. Naturally, as the years flow by, Steve's appreciation of the wilderness grows, along with his skills as a wilderness canoeist. His observations become more detailed, more fish are caught and scenery and wildlife sightings are less about the thrill of encounter and more about the complexity of relationships that swirl in the wild landscape. The paddling, portaging and camp craft become polished routines that offer the deep satisfaction of a job well done.

If this memoir were only a description of Steve's wilderness experiences or an account of the history of the Boundary Waters Canoe Area Wilderness, it would be a satisfying and rewarding read. But it's much more. Within these three decades of canoe trips, Steve explores and reveals his relationships with his father, brothers and friends—but especially with his father. In the juxtaposition of these two stories, a deeper meaning is revealed. The high moments (a paddle across a moonlit lake, the sound of wolves howling, approval in a father's voice) and the low moments (an overturned canoe pinned in rapids, a swarm of tormenting mosquitoes, a painful divorce) become a metaphor for all of life. Rarely do good things come without great effort. Pain and conflict are the context for happiness,

and finally, at the end of the trail, love and companionship are the memories that are treasured.

Although I've canoed the wilderness with Steve only once, his wilderness experience has informed our relationship. For more than fifty years, I've spent the canoeing season talking to people who are either beginning or ending a wilderness canoe trip here at Sawbill Canoe Outfitters on the southern edge of the BWCA Wilderness. I've always felt that the people who enjoy wilderness are an unusually agreeable and interesting group. For starters, everyone looks the same. They all wear sturdy, practical clothing and talk about scenery, wildlife, weather and fishing. Most, if not all, of the normal social cues to class and culture are missing, so people meet one another as simply human, with most cultural preconceptions stripped away. Out of the thousands of people I've met in the context of our family's business, a few have become treasured friends. This chemistry is somewhat mysterious, but as the years go by, I realize that it is, more often than not, recognition of a kindred spirit in a deep and abiding love of wild places. Steve, his father, Larry, and I connected on that level many years ago, and that connection has sustained a wonderful friendship. Even though we see each other only briefly each year, this attenuation along the same wavelength has created a strong and lasting bond.

The greatest joy of this book for me is how it leads my mind to the magic wilderness memories I share with my family. I was very lucky to be born to parents who decided (I'm still not entirely sure why) in 1957 to start a canoe outfitting business on the edge of what would become the BWCA Wilderness. Although I enjoyed many wilderness canoe trips with my parents, my best memories of them revolve around the business. They were successful, but unusual, businesspeople in their commitment to putting people before profit. They were physically and emotionally generous, with both customers and crew, and always mindful of the real benefits of wilderness canoeing—peace, solitude, renewal and a new perspective on modern life. Like Steve's family, and all families, the way was not always smooth, but it is the rough water that makes the smooth water so sweet.

Unlike Steve, I rarely kept journals of my trips with my family or even took many pictures, for that matter. I always preferred to let the memories be the record of our trips, and I have many that are precious. While reading this book, I remembered lying in the bottom of the canoe with my son Adam on Cherokee Lake when he was five (and up well past his bedtime) watching the stars, satellites and meteors. I remembered my daughter Ruthie swelling

with four-year-old pride and confidence when she overheard a group of women we met on a portage comment that the pack she was carrying was larger than the packs they were carrying. I remembered my daughter Clare carefully stowing her paddle near the end of a long day of travel in torrential rain and explaining that she was not paddling anymore because she wasn't ready for the trip to end. I remembered being huddled under a tarp with my son Carl at the base of a huge waterfall in a very remote Canadian wilderness as lightning raged around us and rain fell so hard that we couldn't see our tent ten feet away—and the huge relief we shared when the storm left us unharmed. I remembered listening to a howling pack of wolves chase a moose into the water less than fifty yards from the tent where my wife, Cindy, and I cuddled closer with each other and with our normally outgoing retriever, who was suddenly very meek.

If you have memories like these, they will be evoked as you read this book. But more importantly, you will be inspired to create new memories and to establish traditions that lead to deeper appreciation for this fragile planet and the people you love. So cinch up the pack straps, slide the canoe into the water, gather the paddles and life vests and embark on this journey of love.

Bill Hansen
Sawbill Canoe Outfitters
Sawbill Lake
March 2011

PREFACE

Located on the northern border of Minnesota within the 14,500-square-mile Rainy Lake watershed, the Boundary Waters Canoe Area Wilderness comprises more than one million acres of protected forests, lakes and streams. To the east lies Lake Superior, to the west Voyageurs National Park and to the north Canada's Quetico Provincial Park. When you launch your canoe in Sawbill Lake, as canoe outfitter Bill Hansen says on the back of his old map, "It is exciting to know that you could keep paddling north through unbroken wilderness all the way to Hudson Bay."

More than 200,000 of us visit each year. Why do we love this area? Why should it be protected? What makes it unique? Who were the people who paddled these waterways and walked these trails before us? And who do we have to thank for saving this remarkable region from exploitation and development? These are the questions I hope to answer concerning the history of this remarkable place. But I also want to tell the story of how the Boundary Waters has become a part of me, how it has informed my identity, seeped into my soul, inserted itself into my dreams and helped me understand and appreciate my relationships with some of the most important people in my life.

When we enter the Boundary Waters, we enter a unique realm, a "precious and picturesque…combination of water, rock, and forest, all linked together in a single maze of bewildering beauty," as explorer and wilderness advocate

Ernest Oberholtzer described it. But it's more than beauty, and it's more than scenery. "Scenery is something you have merely looked at," Paul Gruchow reminds us in *Boundary Waters: The Grace of the Wild*. "Place is something you have experienced."

The Boundary Waters is both a place and an experience. It invites us to relax and enjoy the beauty and rhythm of the natural world. It offers timeless adventure with people we love (or at least like), memories of people who one day will no longer be with us and a reminder of what it is to be young at heart, to remain curious about the unexpected, the unplanned and the uncontrollable—in other words, to be open to the wonder of life.

The personal side of this story begins and ends with my dad. Although not every trip we took was easy, we've had some of our best times in the Boundary Waters. Our ventures into the wilderness were more than paddling and exploring; more than lugging our gear across the portage trails between lakes; more than fishing, finding a campsite, creating a temporary home for the night beneath the towering pines, gathering firewood, cooking, sharing meals, cleaning up and falling asleep to the rising sound of loons chorusing across still lakes. Canoeing was also time set apart, time taken together.

At the time of this writing, I've taken sixty-two trips to the Boundary Waters Canoe Area Wilderness, as well as four trips to the wilds of Canada as a Boy Scout and one with my wife, Debbie, to Quetico Provincial Park. All told, I've spent about one year of my sixty-one years there. I hope to make it two before I die. I've canoed with my brothers, my son, my daughter, my son-in-law, a sister, a niece, two nephews, a friend and his nephew, two friends and their daughters and a host of other friends, including a canoe outfitter and my men's group. But throughout these years, my most constant and loyal companion has been my father, who for twenty-nine years, no matter what else was going on in his busy life, took time to canoe with me in the wilds of northern Minnesota.

1
BEGINNINGS AND MIDDLES
WITHOUT ENDINGS

When we visit the Boundary Waters, we become part of its history. It's a story worth telling, about a place worth preserving.

The natural history of the Boundary Waters Canoe Area Wilderness begins some 4.6 billion to 600 million years ago, during the Precambrian period, when the granite bedrock was pressed and shaped into the great Canadian Shield that underlies the border lakes region. That same bedrock later thrust itself to the surface in dramatic outcroppings and shorelines that lend the area its rugged beauty and enduring character.

Some 2.5 million to 10,000 years ago, during the most recent ice age, the ferocious weight of an ice layer up to two miles thick scraped, gouged and excavated the landscape into a network of lakes and ponds, rivers and streams and bogs and marshes, conveniently spaced and interconnected for travel. From 5,000 to 300 years ago, the Old Copper people transported their game along these waterways back to their villages, and from 1690 to 1865, the French voyageurs followed these same routes to haul out beaver pelts for the European markets.

The story is rewritten and revised every time you or I launch a canoe and take that first stroke of the paddle, powered by our own muscle and determination, entering a realm not pristine and not untrammeled but protected and preserved, a place where the natural order of things, though altered, predominates.

The story for Dad and me begins in 1978, when we drove from Iowa City to Duluth and then followed the meandering North Shore Scenic Drive along Lake Superior. At Tofte, little more than a Standard Oil Station back then, we turned left onto the Sawbill Trail. Soon leaving pavement behind, we drove twenty-four curving miles, up and down hills and past stands of giant white pines to the trail's end at Sawbill Lake, which takes its name from merganser ducks, divers with serrated sawtooth edges on their hooked beaks used for grasping fish. There we rented a canoe, paddles, life jackets, Duluth packs and other equipment from the Sawbill Canoe Outfitters, owned by Frank and Mary Alice Hansen. Then we doubled back down the trail to launch ourselves from a sandy beach into the clear water of Kawishiwi Lake, dipping our paddles "into liquid sapphire," as Florence Page Jaques describes it, on a cool, sunny August afternoon. My older brother, Larry, was with us on that trip, as he was on four other trips. Over the years, various family members and friends would make up our party, but mostly it was my dad and I sharing an adventure, sometimes just the two of us.

Kawishiwi Lake was where we crossed that invisible boundary separating civilization and wilderness. Sigurd Olson comments on the word "Kawishiwi" in *The Singing Wilderness*:

Frank Hansen in front of the old Sawbill Canoe Outfitters store.

Canoeing Across Time

To the Chippewas that sprawling series of lakes and rivers known as the Kawashaway was a land of mystery. Bounded by brooding stands of pine, its waters were dark, their origins unknown. According to the ancients, the land belonged to those who had gone, was forbidden to those who lived. From the Algonquin Kaw meaning "no" and Ashaway meaning "the place between," it took its name: "no place between," a spirit land.

No place between. A place between the living and the dead. Was it also a place between the past and the future? Between childhood and adulthood, youth and old age?

On our first afternoon, we paddled and portaged from Kawishiwi to Polly, a hub lake with fourteen designated campsites. By the time we arrived, it was late afternoon. Checking our map for the campsite locations, we paddled from one site to another, looking for one that was available. To our chagrin, all were taken. Tired and hungry, we had no choice but to push on through three more portages to Koma, where in the early evening light we arrived exhausted. Finally, to our relief, we found an open site on the south shore. Our first Boundary Waters campsite.

Steve and his older brother, Larry, loading a canoe on Kawishiwi Lake in 1978.

By the time we had pitched our tent, gathered wood and cooked our dinner, it was nearly dark. As Larry and I sat and Dad stood eating, we were assaulted by hordes of mosquitoes. To make matters worse, the juice from our frozen steaks had leaked and coated the contents of our canvas Duluth food pack, so throughout the entire trip we carried sticky plastic bags that, despite repeated rinsing in the lake, retained a rancid, sickly odor.

The few photos Dad took of that first Boundary Waters trip have faded to a red tint. Several years ago, he gave me his collection in a cardboard box. He had mounted the pictures in plastic covers and labeled them by year. He was clearing things out, he said, and he wanted me to have them. There's one picture of the two of us by the campfire. I'm sitting; Dad's kneeling. When this photo was taken, I was twenty-nine. Dad was fifty-three, eight years younger than I am today. At the time, he looked like an old man to me. Today, I realize how youthful and fit he was.

Another picture shows Larry in a yellow raincoat and a stocking cap. He is turned around in the bow of the canoe holding a huge northern pike, looking proud. Larry was the first person in our family to experience wilderness canoeing. He had canoed the wilds of Canada north of Toronto as a Boy

Steve's dad at fifty-three on their first Boundary Waters canoe trip in 1978.

Larry looking proud with his northern pike.

Scout in the early 1960s. It was Larry who told me about muskeg. "It's like quicksand," he said, "except it's a mass of mud and plants floating on the water. If you don't watch out, you punch right through."

It was a new concept to me, muskeg, and I was fascinated. I loved the sound of the word. Any place with muskeg must be a really neat place. I thought so then, and I think so now, nearly half a century later. Imagine, a place with floating land. With every step, you might punch through this fragile boundary to something unexpected.

My memories of that trip with Dad and Larry have faded. I didn't start keeping a log until later. But I remember how tired we were that first night. I remember the mosquitoes, the rain and the smelly plastic bags. I know where we camped because Dad gave me the map he used to mark our route. On later trips, I followed his lead, marking our annual routes in different colors. Every four or five years, the overlapping lines would become confusing, and I would buy a new map. On some of the maps, water from rain and splashing paddles blurred the color-coded lines, making it hard to distinguish the red lines from the purple and blue ones. Did we camp on the south shore or on the peninsula jutting from the west shore of Koma Lake? Did we stay on

A map marking their early routes west of Sawbill.

Kawasachong or just take a day trip there? Was it on my friend's nephew's first or second trip when we heard the wolves howling on Kawishiwi River? Now, as I look at these old maps, I wonder why it's so important for me to know. Why does it matter? As the naturalist Henry David Thoreau reminds us, most of our lives are forgotten in the living, and I guess that's as it should be. Still, it's nice to have a record.

The three of us covered a reasonable distance that year. From Koma, we paddled to Malberg, took day trips to the Kawishiwi River and up the Louse River to Boze Lake and then headed back to Square Lake for our last night before taking out.

It wasn't an easy trip. It would have been easier to view the great outdoors from the comfort of a snug cabin, to motor across the lake to a secluded campsite or to be transported by pontoon plane to a favorite lake, as once was common. In the 1940s, planes shuttled visitors to nearly twenty resorts operating on Basswood, Crooked, Knife, La Croix, Saganaga and Seagull Lakes, some offering amenities such as bars, slot machines and motorboats. The town of Ely to the south was the largest inland seaplane base in North

America. Even wilderness advocate Sigurd Olson once took a lift. But as he explains in *The Singing Wilderness*, he was disappointed by the experience:

> *The pilot threw out my pack, and I scrambled along the pontoon and jumped for the rocks. A farewell push and the wings turned toward the open lake once more. The engine roared and the plane moved out in a cloud of spray. A moment later it was in the air over the ridges, heading back toward town. I glanced at my watch. It was exactly thirty minutes since we took off and here I was alone, as I had planned it, deep in the heart of the wilderness at a point that normally would have taken several days of hard travel by canoe…At first I could not realize the change, so violent had it been. Formerly, by the time I had reached this spot on the map, the country had had a chance to soak in and become a part of me. But as I stood listening to the drone of the plane, I knew that I was still part of the environment I had left and that it would take time for the old feeling of wilderness to come.*

Nearly half a century later, Paul Gruchow would come to a similar conclusion:

> *No engine yet devised can speed the workings of the spirit. If you have hurried to get into the wilderness physically, still you will not be there mentally or emotionally…Hurtling into the wilderness under engine power saves no time at all if it is the experience of the wilderness you are after; it may, in fact, waste time.*

Dad, Larry and I entered and exited the Boundary Waters under our own power on that 1978 trip, and in doing so I began to sense something I now know with certainty. We discovered something that brought us back. Canoeing with my dad was an opportunity to repair a relationship damaged by the silence of a sometimes distant father and the resentment of an angry adolescent son. Now, as I think about it, I realize that I've spent more hours of my adult life with him in the Boundary Waters than I have in civilization. It was in the wilderness, swatting mosquitoes and "eating cardboard food mixed with swamp water," as my neighbor across the alley describes our cuisine, that I forged an adult relationship with a person who has grown wiser, more loving and more important to me with each passing year.

2
Changing Times, Early Humans, Ice Age Animals, Native American Populations, Explorer P.G. Downes, Eagles and Brilliant Stars

The next year, my younger brother, Tim, joined Dad, Larry and me for his only trip to the Boundary Waters. We put in at the same starting point, Kawishiwi Lake, off the Sawbill Trail, but this time we extended our trip from seven to ten days. Rather than doubling back to Kawishiwi, we traveled on from Polly and Koma to Malberg and then up the Kawishiwi River to Little Saganaga, Tuscarora, Missing Link, Snipe, Long Island and Sawbill.

Dad's old photos remind me of how the Boundary Waters has changed, sometimes in ways I didn't notice from one year to the next. Gone now are the canoe rests along the portage trails and, except here and there, the canoe landings at the end of the trails. Gone, too, are the unpainted, weathered gray poles supporting signs marking the portage trails. The poles stood four or five feet tall and about as big around as a large sapling. Mounted on top was a flat piece of wood carved with letters of the next lake's name and the portage length in rods. (A rod is sixteen and a half feet, which, as Mary Alice points out in *Sawbill: History and Tales*, is the approximate length of a canoe.) Although simple and rustic, these portage markers have since been removed to preserve the natural wilderness look of the area. I think that was probably the right thing to do. Still, I miss seeing them.

Many "improvements" and conservation projects in the lakes region along the Minnesota-Canada boundary occurred from 1933 to 1942 under the

Larry and Tim in a canoe in 1979.

The three brothers, (left to right) Larry, Steve and Tim, in 1979.

Larry portaging with an old portage sign in the foreground.

Tim portaging.

aegis of the Civilian Conservation Corps (CCC), which enlisted thousands of unemployed men to plant trees, rebuild and improve portages, construct canoe rests, install landing docks, post direction signs, build four lookout towers and fight forest fires. Fourteen major camps, each housing approximately two hundred young men and dozens of highly skilled outdoorsmen, were constructed. The docks, signs and rests were later removed to comply with the 1964 Wilderness Act. Still evident are raised walkways, rocks placed to reinforce trails, a few canoe landings (now mostly submerged) and other signs of trail improvements.

Another photo shows my brothers and me sitting at a picnic table. The first picnic tables were also built by the Civilian Conservation Corps. "Constructed in place, they were massive, half-log jobs," Bill Hansen once told me, "but they rotted fairly quickly because they weren't painted or treated." Until the 1990s, picnic tables made from dimensional lumber were common on some of the larger lakes, such as Cherokee and Long Island. Flown in or hauled in by motorized boat, they were comfortable, convenient and…well, downright civilized. That was the problem. They also were intrusive, more so than the fairly inconspicuous portage signs. Now they, too, are gone. In their place is "camp furniture," logs arranged by campers around the fire grates. Sometimes these logs have been flattened on the top side by hand axe. Although the Forest Service discourages constructing them, camp furniture is found at nearly every campsite.

These changes, however, are relatively insignificant in the grand scheme of things. The first humans—including the Clovis people, or the Big Game Hunters of the Paleoindian Tradition, who migrated into the region between twelve thousand and eight thousand years ago—hunted woolly mammoths, mastodons, giant ground sloths, muskoxen, horses, camels, giant beavers and giant bison. Imagine ice age megafauna like saber-toothed tigers, one-thousand-pound short-faced "cave bears" or dire wolves with their massive teeth wandering onto your campsite today.

As the planet continued to warm, other dramatic changes occurred. White pines began a slow, seven-thousand-year migration from Appalachia, where they had taken refuge during the glacial era, returning to the border lakes region sixty-five hundred years ago. The Old Copper people—so called because they made tools, implements and weapons from copper they mined on Isle Royale and possibly near Minong, Wisconsin—arrived between five thousand and three thousand years ago. From twenty-eight hundred to three hundred years ago, Indians of the Woodland Tradition—so named because

they depended on forest products and hunted, fished and gathered food such as wild rice for their survival—were the predominant culture.

It was during the latter part of this era, sometime between one thousand and five hundred years ago, that birch-bark canoes replaced the heavier, more cumbersome dugout canoes, thereby significantly increasing the mobility of the region's inhabitants. In *Paddle North: Canoeing the Boundary Waters–Quetico Wilderness*, Greg Breining explains their advantage:

> *A bark canoe weighs a fraction of what a dugout does. Now, a single person could paddle this radically nimble boat to the end of a lake and, instead of dragging it or leaving it behind, flip it to his shoulders and hike to the next body of water. Rocky shores or impassible waterways no longer prevented people from traveling farther in search of new hunting grounds. People would gain better access to staples such as wild rice and furs. They could travel more quickly, in smaller groups, in response to changing conditions and the seasons.*

The one disadvantage of bark canoes was their relative fragility, but as Breining points out, they "could be completely rebuilt within a day with materials found in the forest."

About this time, from one thousand to four hundred years ago, the Dakota Indians migrated northward into what is now Minnesota. During the 1600s, they became the dominant culture, except in the extreme northern border region. Northeast Minnesota was inhabited by the Cree and northwest Minnesota by the Assiniboin, a branch of the Sioux Nation. The next major movement occurred in the late 1600s, when the Northern or Salteaux Ojibwe (one of four groups of Ojibwe or Anishinabe), fleeing westward from the Iroquois, migrated in increasing numbers into the Boundary Waters region. As a result of an alliance encouraged by French explorer Daniel Greysolon (Sieur du Lhut), the resident Dakota and the arriving Ojibwe lived peacefully for more than fifty years. Then, in 1736, the Dakota attacked and killed a party of Cree and Frenchmen in an attempt to discourage trade between the two groups, trade that was providing guns to Dakota Indian rivals, both the Cree and the Assiniboin. In response to this attack on their allies, the Ojibwe went to war against the Dakota and, after winning three decisive battles between 1740 and 1760, displaced them as the dominant culture.

A part of Native American history that has long fascinated me is the Ojibwe migration story. When the Ojibwe arrived in the border lakes region

toward the end of their five-hundred-year westward migration, they were doing more than escaping the dominant Iroquois. They were also following a prophecy that, at the end of a seven-stage journey, they would find a new home marked by a turtle-shaped island, where food grew from the water (wild rice). Before settling on Madeline Island (which is in fact shaped like a turtle, with its oversized head stretching to the east), they had divided into two groups at the eastern end of Lake Superior. One group continued its migration along the north shore, the other along the south. As they circled the great inland sea, the two groups were separated for generations, until the southern group encountered the northern group living on Spirit Island in the estuary of the St. Louis River, near present-day Duluth and Superior. The two groups didn't recognize each other until they began sharing their creation and migration stories. Imagine the looks on their faces, illuminated by the flickering light of their campfires, when they realized they were members of the same tribe.

During this time, the estimated population of Native Americans in the Great Lakes region was relatively large, between 60,000 and 117,000 people. Tragically, in 1780–82, smallpox, a disease brought to the New World by European settlers, decimated their numbers. Estimates of fatalities varied, ranging from 50 percent in some villages to as high as 95 percent in others. People died in such overwhelming numbers that there weren't enough survivors left to care for all the bodies, and there were reports of animals feasting on corpses and wolves attacking weakened survivors.

As a result of this calamity, white settlers who later moved into the region may have gotten the impression that this undeveloped area was largely unpopulated, and this misperception may have fed their belief that the land was theirs for the taking. Years later, when the Boundary Waters was set aside as a protected area, this lingering assumption may have contributed to the modern definition of wilderness as a place that is not only natural and unspoiled but also "untrammeled"—that is, void of residents.

In 1783, life changed for Indians and whites alike. With the signing of the Treaty of Paris at the conclusion of the American Revolutionary War, the British surrendered control over lands west of the Appalachian Mountains, and the United States gained sovereignty over the southern Great Lakes region. In 1854, seven chiefs of the Chippewa Indian Peace Commission traveled to Washington, D.C., to sign the Treaty of LaPointe, ceding the entire Arrowhead region of northeastern Minnesota to the United States government and opening the area to exploration and development by white

settlers. Small reservations for the Ojibwe of Lake Superior were created at Grand Portage, Fond du Lac and Nett Lake. In return for giving up their land, the Ojibwe were promised monetary payments for twenty years, as well as annual food supplies, eighty acres of land to each head of family, fishnets, guns and ammunition, agricultural teachers and a blacksmith for each reservation.

Farther north, however, Native Americans continued to occupy vast territories. In 1912, when Ernest Oberholtzer and his Ojibwe guide, Billy Magee, paddled "toward magnetic north," setting out at the end of the railroad line at Le Pas, Manitoba (west of Lake Winnipeg), they entered unmapped territory that had not been visited by a white man since Samuel Hearne canoed the region in 1770. As recently as 1939, P.G. Downes and his companion, John, a white trapper from Wollaston Lake, routinely came across quartz shavings and arrowheads when they traveled north by canoe into the rugged Canadian Barrens to Nuelton Lake, approximating the first segment of Oberholtzer and Magee's route.

Downes realized that more frequent exploration and penetration by airplane of this still wild territory would bring diseases borne by whites, against which the native population had little natural resistance. In *Sleeping Island*, considered by some to be the best canoeing book ever written, he describes a region in transition: "Here was the world as it had always been, untrammeled, undefeated, a true frontier, one of the last on the continent— going but not yet gone."

The Chipewyan and Cree whom Downes encountered used rifles, mosquito netting and outboard motors, but they also continued the old ways, living in semipermanent winter camps and moving north for the summer in a migration that had occurred for thousands of years. One recently vacated winter camp looked much as it would have long ago: "Old tipi poles were still standing, most of the trees had been cut for firewood, the ground was littered with caribou bones, many of them slit lengthwise for the marrow, and the whole area was deep with white caribou hair and many torn fragments of hides." At another camp, they found "cracked caribou bones" and "tufts of white caribou everywhere," as well as something that combined both old and new technology: "a spear for killing caribou" that "was crude but effective-looking with a long steel point affixed to a peeled wooden handle by a thong, about five feet long."

To make certain they were following an established route and not lost among the region's myriad lakes and channels, Downes and his companion looked for "camping evidence" left by contemporary inhabitants:

These campsites and signs of Indian travel were very important, for we had picked our way along by them. When they disappeared for any real length of time, we could be fairly sure that we were getting off the track. It demanded endless vigilance, acute observation, and the ability to distinguish between winter and summer camps. Winter routes often do not follow the water course, particularly running water, and they tend to cross the country from lake to lake. These signs are not obvious and at times consist only of a stick thrust into the ground, a small patch of ashes, or a few cuttings. If the small trees showed ax marks and had been cut off two or three feet above the ground, we could be sure that the camp had been a winter one, for the depth of the snow caused the tree to be cut at that height.

Summer routes might be marked by the impression of a canoe left in sand, a cut branch or a piece of spruce bark hung from a branch, its freshness indicating how much time had passed since it had been cut by other travelers.

In contrast to these nearly imperceptible markings, my dad, my two brothers and I were guided by wooden signs on shorelines marking the portages and by mostly accurate maps with red lines indicating trails and red dots designating campsites. At those campsites, we found fire grates and biffies (outhouses without the house) that helped smooth the roughness out of "roughing it." In contrast to dugout canoes or even Downes's canvas canoe with its stout oak keel, our aluminum canoes were relatively lightweight, weighing only sixty-eight pounds.

We also traveled with a nylon four-person Timberline tent that was lightweight and easy to pitch. I loved that tent, but my favorite tent was my first. Unlike Dad, whose family could afford few luxuries during the Depression years, my brothers and I (and later our two sisters) were showered with presents for Christmas. One year, we discovered a green canvas tent under the tree. We pitched it everywhere—in the basement, in the backyard and, when we got a little older, in "the woods" at the end of Mount Airy Avenue, a dead end street in the Cincinnati suburb of Montfort Heights.

That little woods was our wilderness. It was on a hillside beyond a field of weeds and a gravel-bottom creek that would flash flood after anything more than a moderately heavy rain. Beyond the woods was a wire fence we could clear in a heartbeat, an old farm with some small weathered outbuildings and a pond with an island where we went ice-skating in the winter. With our neighborhood gang, we spent countless hours exploring what seemed like a vast undeveloped area, climbing trees, building forts and tree houses,

digging pits and covering them with branches and grass roofs and catching toads, frogs, snakes, salamanders, crawdads and anything else we could get our hands on and keeping them for pets.

Given our love of the outdoors, it was natural for my brothers and me to join the Boy Scouts when we moved to Wyoming, another Cincinnati suburb. Our scoutmaster, Cyril J. McCarthy, or "Mac" as we called him, was a capable outdoorsman. He worked for a small electrical company, and his boss gave him four weeks off every summer. One weekend every winter month, he would take us camping around Cincinnati, and twice each summer he took us on two-week trips to Ontario—one trip camping with the entire troop, the other canoeing lakes such as Biscotasi and Misssanabie with the boys who were fourteen and older.

It was Mac who taught us how to cut and split wood with a hand axe, make shavings and start a fire with one match, even in a pouring rain. He taught us how to paddle a canoe, pitch a tent, fashion tent stakes from split wood and tie a bowline, clove hitch, two half hitches and other useful knots. He taught us how to plan a menu, cook a meal and get the soap scum off the metal plates so we wouldn't get the runs. Actually, it wasn't Mac but the older boys under his supervision who taught the younger boys these skills. By the time the boys in our troop were fourteen years old, most had developed enough self-reliance to take care of themselves in the woods. They also grew up knowing their way around a kitchen.

Unlike us, Dad never camped as a boy. But where he grew up in Covington, Kentucky, a small town across the Ohio River from Cincinnati, he had the run of the neighborhood, as well as easy access to the river. One of his favorite places to play was a hollow known as Willow Run. It began a couple blocks to the west of where his street ended, and it extended north to where I-75 now crosses the river.

One night by the campfire, Dad told me the story of one his more daring boyhood adventures. During the great flood of 1937, he said, the river came within one block of his house. Willow Run was completely under water. So he and his friends did what kids anywhere would do. They gathered driftwood and planking and built an eight- by eight-foot raft.

"We went no farther than the hollow," he said, "but we felt like true adventurers."

"Did your parents ever find out?" I asked.

"No," he said, "they never did."

On the second day of our canoe trip—with Tim and me in one canoe and Dad and Larry in the other—we paddled across Koma Lake toward Polly and the Kawishiwi River. By some trick of memory, I remember that paddle as though it were yesterday, maybe because Koma was where we had spent our first night in the Boundary Waters the year before. Or maybe it was because we spotted an eagle there.

"Look," said Tim. He was pointing to a jack pine on the northwest shore. All four of us stopped paddling and sat in silence, awed by the sight of so magnificent a bird. To think, we were seeing an American bald eagle not in a zoo but in its natural surroundings. Back then eagles were still recovering from the pesticide DDT, which weakened the shells of their eggs. In 1973, the same year DDT was banned, a survey found only 115 active bald eagle nests in Minnesota. To see one in 1979 was a rare and wondrous sight.*

While admiring this majestic creature, we saw a white flash and what appeared to be a large branch falling from the tree. It took a moment for us to realize it wasn't a branch. The eagle had taken a shit. A very large shit. I still think of the American bald eagle as a noble bird, but now I have this other image impressed in my memory.

Another memory stands out. A few days later, my two brothers and I paddled out on a small lake, probably Snipe. It was night. Miles from any cities or towns, there was no ambient light. The stars were brilliant, both above us and reflected in the still water below.

When we paddled slowly back to our campsite, guided by the light of the campfire, Dad joined us on the shore. We hauled the canoe up on the shore and turned it over, and then the four of us stood in the cool night air, our heads cocked, taking in the celestial show. As we gazed at the countless stars, we felt small and insignificant but also comforted, reminded by their presence that we were not alone.

On every trip since then, Dad comments on the Milky Way, how distinct it is and how clearly you can see it in the Boundary Waters.

"You know," he says, "most people will never see the Milky Way in their lives."

It's one of his favorite observations. Today, I can't look up at the night sky without hearing his voice.

*. In 2007, there were approximately thirteen hundred pairs of nesting American bald eagles in Minnesota. That same year, eagles were removed from the Federal Endangered Species Act's list of endangered and threatened species. Minnesota has the largest population in the lower forty-eight states. Florida ranks second and Wisconsin third.

3
BEAVERS AND VOYAGEURS

The next year, 1980, I turned thirty-one in the Boundary Waters. Unbeknownst to me, Debbie had slipped Dad a birthday card and a candle. Along on this trip were my brother Larry and the adolescent son of one of his friends, who was in the process of getting a divorce.

We put in at Sawbill and paddled across the bay to the portage to Alton. While walking the short thirty-rod trail, I noticed how wide it seemed compared to other portages. As Bill Hansen points out on his map, a hand-operated, narrow gauge railroad once ran across it. The railroad had been constructed to haul steel and other construction material for a fire tower on Kelso Mountain, just west of Kelso Lake. For years afterward, travelers used the tracks and an old railcar to move their boats and gear from one lake to the other.

From Alton, we headed up the Lady Chain and from there went all the way to Gabimichigami, then looped back to Sawbill via Kelso. On August 13, midway through our trip, Dad stuck the candle in a dried prune. Then he led the group in singing happy birthday and handed me the card. I felt like a kid. It was one of my best birthdays ever.

One night after dinner, Larry and I took an evening paddle in search of beaver. Our method was to paddle to the east side of the lake and look across the water to the west, where the wake they made as they swam would be illuminated by the setting sun. Before long, we saw the tell-tale lines. As we approached, there was a smack and a splash, which made us jump.

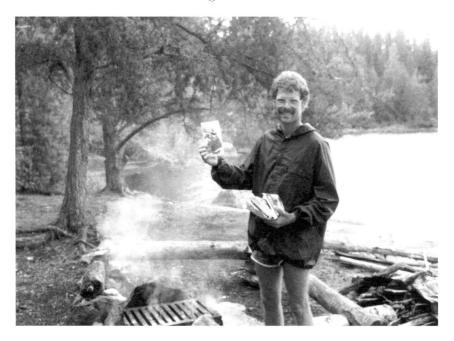

Celebrating Steve's thirty-first birthday in the Boundary Waters.

In recent years, beaver populations have fluctuated. During a three-hundred-year period, their numbers were drastically reduced by trapping. Beaver pelts were at the heart of the fur trade, which began on the eastern seaboard of what is now Canada in the 1500s, when the Native American populations traded them for kettles, knives and other tools and weapons from French explorers and fishermen. It expanded greatly in the 1600s, when felt hats made of beaver fur became fashionable in Europe. The trade was carried on between the Ojibwe and the French voyageurs, robust men hired by the Hudson's Bay Company, incorporated by British royal charter in 1670, and by the North West Company, headquartered in Montreal from 1779 to 1821, when the fur trade was at its peak. In *Our Historic Boundary Waters*, Duane Lund describes their legendary strength:

> *Each* [voyageur on a fur trading expedition] *was expected to carry eight 90-pound bales (usually two at a time). However, as a bonus for anything over that load, they were paid one Spanish dollar per bale. A normal load of two bales at a time meant a total of 72 miles of portage, so the stronger men would try to take more…The stronger voyageur carried as*

many as three or four of the 90-pound bales at a time. The men kept their balance by leaning forward and trotting at a fast pace. Passengers traveling with the voyageurs recorded that they were hard pressed to keep up, though empty-handed.

According to Lund, the record haul was reportedly the result of a wager. It was won by a voyageur "who carried 820 pounds (more than nine bales) uphill for one mile!"

Dressed in colorful garb and singing songs to ease their burdens, the voyageurs hauled their furs—the pelts of otter, fox, mink, martin, wolverine and other animals but mostly beaver—over the inland lakes and across the portage trails to the meeting place at Grand Portage, near Lake Superior. From there, the furs were transported north to Hudson Bay, and from there they were shipped to Europe. Not until the 1820s, when silk hats replaced felt hats, did the intense pressure from trapping ease.

By the end of the nineteenth century, the beaver, fisher, marten and wolverine had all but vanished from the border lakes region. The beaver population didn't begin to recover until the 1920s, and it didn't fully reestablish itself until the 1970s. The fisher population began to recover in the 1950s, the marten in the 1970s. The wolverine is still absent.

4
RIVER CANOEING AND ERNEST OBERHOLTZER, THE LITTLE MAN WHO DEFEATED AN INDUSTRIAL GIANT

The following year, 1981, was the only year we didn't canoe the Boundary Waters. Instead, Dad, Larry and I paddled the Namekagon River (pronounced Na-ma-KAW-gon). The Ojibwe word *Namekagon* means "the place of the sturgeon" in English.

It was my idea to canoe a Wisconsin river rather than the lakes of the Boundary Waters. I don't recall my reasons. Maybe I was thinking of the time I had paddled the Red River Gorge in Daniel Boone National Park, near Stanton, Kentucky, in 1971, with Dad and a group of engineers from his General Electric lab in Evandale, Ohio. That was my first canoe trip with Dad, and it ended up being one day longer than planned. I remember the downpour on our first evening and how we were awakened in the middle of the night by gurgling water. The rapidly rising river was at our tent doors. We broke camp in the rain and scrambled to higher ground, huddling on the steep slope until daybreak, when we discovered to our dismay that the raging river had risen fifteen feet during the night. After waiting a good part of the day for the water to abate, we ventured onto the torrent. The more ferocious rapids we portaged around; others we attempted to shoot. On one run alone, six of the eight canoes capsized.

Before one set of particularly fierce rapids, Dad and I debated whether we should attempt them. I was about to say, "I don't want to do this" when Dad said, "Let's give it a try."

Halfway down, I lost my nerve. "Let's pull out," I hollered from the back of the canoe.

We back-paddled furiously and grabbed onto a big flat rock by the shore. I was wondering how we were going to get ourselves and our canoe out of the water when my fingers began to slip across the smooth rock. Snatching my paddle, I thrashed at the water, but the current caught the stern and slowly but steadily drew my end of the canoe away from the shore. Suddenly, we were broadside in the current, then backward, our bow facing upstream.

"Turn around!" Dad yelled.

Dropping to our knees, we paddled for our lives. We banged over a large rock in the rushing river, then another and another, stern first, the white water churning and sloshing over the gunwales as we bumped and bounced our way down the chute. And then it was over. We were gliding in a pool of slack water. The roar of the water had ceased. Limp with relief, we sat without speaking, shaken, but also proud we had made it without capsizing.

During the entire trip, Dad and I were in the only canoe that never capsized. Miraculously, no one drowned or was seriously injured, although one person was hospitalized with a severe reaction to poison ivy. Dad and I survived our ordeal with a great story. Over the years, we've enjoyed telling it to whoever will listen.

But it wasn't that sort of extreme adventure I had in mind in choosing to canoe the Namekagon. Maybe I was thinking of how much fun it would be just to paddle and drift in a fast-moving—but manageable—current. Shooting occasional rapids is a kick, especially after you get the hang of spotting the *V*s formed by rocks lurking just beneath the water's surface.

To take advantage of high water from spring runoff, we went in May. We put in at Hayward, Wisconsin, and took out at Riverside on the St. Croix River, which in 1972 had been designated a National Scenic River. It was cool during the day and cold at night. On the first mornings, we awoke to a skim of ice in our plastic drinking water jugs. Later, the air began to warm. The alders and birch along the riverbanks burst into bloom. Drawn to the water, the white-tailed deer seemed unperturbed by our approach. When we spotted one, we would stop paddling and drift silently to see how close we could come, sometimes getting within fifteen feet. Our proximity made me realize the advantage that hunting from a canoe would have been for Native Americans.

Compared with lake-to-lake canoeing, river canoeing seemed easy. With the springtime flow of moderately high water, there were occasional runs

of white water, which were thrilling but not dangerous. When we weren't navigating rapids, we could rest anytime we liked. There was always the current, always that relentless power of the river moving us along our way, whether we were paddling or not.

I'm glad we made an exception to our annual trip to the Boundary Waters, but the occasional bridge, road and cabin felt intrusive. I missed the sense of being alone with my companions, deep in the woods, far from civilization. I missed the solitude and excitement that comes from entering a swath of unbroken wilderness. I think what I missed most were my nighttime paddles, gliding silently across a still lake. It isn't practical to meander on a river during its spring flow, when the current is often too strong for a solo paddler. In contrast, on a still lake at night, every stroke of the paddle carries you a long way in any direction you care to go. You can linger as long as you like, knowing you have an easy paddle back to camp. On a fast-moving river, there's no easy return.

My time away from the Boundary Waters made me appreciate it all the more, and I realized the preservation of this wilderness didn't just happen. I knew about Sigurd Olson, had read some of his books and appreciated his role in protecting the region from exploitation and development. I suspected there were others who preceded him.

A few months after our trip, my family and I moved from Iowa City, where I had done my graduate work, to Minneapolis, where I had taken a job at the University of Minnesota, and I began reading books about Minnesota history. From R. Newell Searle's *Saving Quetico-Superior: A Land Set Apart*, I learned about Minnesota's forestry commissioner and "apostle of forestry" Christopher Andrews, who in 1902 set aside 500,000 acres of public domain in Lake and Cook Counties to protect them from logging, mining and homesteading. Much of that area is now part of the Boundary Waters Canoe Area Wilderness. Without Christopher Andrews, one might argue, there would be no Boundary Waters today.

I also learned that in the spring of 1909, the Quetico Provincial Forest Reserve was created by the government of Ontario, setting aside one million acres as a forest and game preserve, and that only weeks later the Superior National Forest was created as a reciprocal act when President Theodore Roosevelt signed Proclamation 848, setting aside one million acres on the U.S. side of the border. Later that same year, an International Joint Commission was created with the signing of a treaty by the United States and Britain (on behalf of Canada) to study and settle disputes between the

United States and Canada regarding use of international waters. In 1913, Quetico Provincial Park was established from the former forest and game reserve. Then, in 1926, what was known as the Superior "roadless areas" of the Superior National Forest were designated as a 640,000-acre roadless wilderness area through a policy issued by the U.S. Forest Service under U.S. agricultural secretary William Jardine.

In 1939, the three wilderness areas of the Superior National Forest were renamed the Superior Roadless Primitive Areas under a plan formulated with the assistance of Robert Marshall, who was in charge of recreation in the Washington office of the U.S. Forest Service. The new designation protected those "Primitive Areas" from development but allowed timber cutting and motorboats. In 1948, the Thye-Blatnick Act, Public Law 733, was passed by Congress, directing the secretary of agriculture to acquire resorts, cabins and private lands within the border lakes region and prohibiting any permanent residents after 1974. Then, in December 1949, President Harry Truman signed Executive Order 10092, creating an "airspace reservation" that banned private flights below the altitude of four thousand feet above sea level, in part as a result of the work of Sigurd Olson, Frank Hubachek, Charles S. Kelly, Bill Magie and other activists.

Finally, it happened. After decades of hard work on the part of countless people dedicated to the preservation of the wilderness character of the Boundary Waters region, on September 3, 1964, President Lyndon Johnson signed the Wilderness Act, U.S. Public Law 88-577, establishing the U.S. wilderness preservation system and prohibiting the use of motorboats and snowmobiles in wilderness areas, except for areas where use was well established. The Wilderness Act defined wilderness as an area "where the earth and its community of life are untrammeled by man…an area of undeveloped…land retaining its primeval character and influence without permanent improvements." This year, 1964, is considered by many to be the birth of the Boundary Waters Canoe Area.

More protection was on the way. On October 21, 1978, the Boundary Waters Canoe Area Wilderness Act, U.S. Public Law 95-495, was signed by President Jimmy Carter. The act added 50,000 acres to the Boundary Waters, increasing its size to 1,098,057 acres, and it extended greater wilderness protection. The name was changed from the Boundary Waters Canoe Area to the Boundary Waters Canoe Area Wilderness. The act banned logging, mineral prospecting and mining; all but banned snowmobile use; limited motorboat use to about two dozen lakes; limited the size of motors; and

regulated the number of motorboats and motorized portages. It also called for limiting the number of motorized lakes to sixteen lakes in 1984 and fourteen in 1999, totaling about 24 percent of the area's water acreage.

So in the decades-long movement to set aside, create and protect the Boundary Waters, some of the principal figures were Christopher Andrews, Theodore Roosevelt, William Jardine, Robert Marshall, Sigurd Olson, Bill Magie, Harry Truman, Lyndon Johnson and Jimmy Carter.

There was another key player in the preservation of the Boundary Waters region: Ernest Oberholtzer, or Ober, as he was known to his friends. A Harvard-educated landscape architect, Ober devoted himself to learning the Ojibwe language and legends and to protecting a region he knew better than any other white explorer. In 1909, when he was twenty-five, he spent a summer paddling three thousand miles of its lakes and streams, photographing moose along the way. In 1912, he and Billy Magee made their historic trip to Hudson Bay and back. Then, in 1925, he and other conservationists were shocked and dismayed when they learned details of a plan to build seven dams in the Rainy Lake watershed.

As Joe Paddock recounts in *Keeper of the Wild: The Life of Ernest Oberholtzer*, lumber baron Edward Wellington Backus wanted to create four main water storage areas affecting parts of the Superior National Forest and what are now Voyageurs National Park, Quetico Provincial Park and the Boundary Waters Canoe Area Wilderness. Water levels would have been raised significantly above natural levels—Little Vermilion Lake would have been raised by eight feet, Loon Lake by thirty-three feet, Lac la Croix by sixteen feet and Saganaga and Crooked Lakes by fifteen feet. The purpose of the storage basins was to provide an even flow of water to the main power dam, so water levels would be lowered and raised according to when the water was needed, leaving behind mud-covered shorelines and vast stands of water-killed trees.

I remember coming across an article published in the *Minneapolis Star and Tribune* on September 13, 1983. Now yellow with age, that clipping is the first of many I have tucked into my Boundary Waters folder. In that article, Ted Hall, former editor of the *Rainy Lake Chronicle*, credits Ober with leading the "crusade that rescued the Boundary Waters Canoe Area from the looters and persuaded a new generation that the alternative to treating our host-planet kindly is to perish with it." As Hall tells the story, Backus "was in for a surprise" when he assumed he would win approval for his project from the International Joint Commission,

*for when Ober raised the alarm, the strongest response came from Backus'
own seat of power—Minneapolis—where Winstons and Wintons and
Heffelfingers and Heads and Kellys and Hubacheks and Pillsburys and
Crosbys rallied to stake out the public's long-term interest in the boundary
waters wilderness. "We preserve our masterpieces of art," they declared
in their opening salvo, "Why not preserve also a few masterpieces of
Primitive America?"*

In a huge victory for wilderness protection, Backus's plan was defeated in
1930 with the passage of the Shipstead-Newton-Nolan Act, signed into law
by President Herbert Hoover. It was the first statute in U.S. history in which
Congress expressly ordered land to be protected as wilderness. The act
withdrew all federal land in the Boundary Waters region from homesteading
or sale, prevented the alteration of natural water levels by dams, prohibited
logging within four hundred feet of shorelines and preserved the wilderness
nature of shorelines.

Despite his brilliant leadership and dogged determination, Ober didn't
get everything he wanted. In "the Program," a plan he had devised to
counter Backus's plan, Ober proposed that the region be protected by a
treaty between the United States and Canada. He suggested designating
the entire ten-million-acre Quetico-Superior region an "International Peace
Memorial Forest" in honor of the men and women who served in the First
World War (and later, those who served in the Second World War). This "vast
international park" would have been "four times as large as Yellowstone and
excluding all economic exploitation." Ober didn't succeed in establishing it,
but if he and his supporters had lost their five-year battle against Backus,
the Boundary Waters Canoe Area Wilderness as we know it today would
not exist.

I sometimes wonder what my adult life would have been like without
ready access to wilderness. It's not that wilderness is the only kind of beauty
I appreciate. I love natural beauty of all kinds, from the band of light
that sweeps across the Grand Canyon at sunrise to the improbable yellow
daffodils in my backyard that proclaim the arrival of spring. Beauty needn't
be grandiose to be important and worth preserving. In *Once Upon a Wilderness*,
Calvin Rutstrum recognizes the elemental beauty of the Boundary Waters:

*Mornings can break so clear, calm, and insect-free that the first awakening
call of a loon over placid water starts a day of serenity, a measure of comfort*

and pleasure that the most idealistically preconceived canoe journey could scarcely visualize. The leisurely paddle along a rock-bound, forested shore can, under these conditions, bring such inspiring surprises and memorable experiences as to leave them etched upon one's memory for life.

I love what the Boundary Waters represents—an acknowledgment of the beauty and sanctity of our natural environment, a window to the way the world once was. Without this "maze of bewildering beauty," my life would be diminished.

AN INVASION OF MICE, FIVE LEGENDARY FIGURES OF THE BOUNDARY WATERS AND MORNING FOG

Although we had enjoyed our Namekagon River trip, Dad and I were happy to return to the Boundary Waters in 1982. Our trip was memorable. On the drive up, we took shelter from a torrential downpour in the Bluefin Bay Grille in Tofte, where we watched the white-capped waves crash into the stone shore of Lake Superior. We fought the wind and the waves on a dangerous crossing of Brule Lake, outsmarted hordes of mice on a Cherokee Lake campsite and paddled from the north end of Sawbill Lake in fog so thick you could barely see the morning sun rising above the water. This was also the year Dad and I took one of our two trips with just the two of us.

Our route was a counter-clockwise loop from Sawbill to South Temperance, Brule, Long Island and Cherokee and then back to Sawbill. After we took the short portage over the rock pile between South Temperance and Brule, we were surprised by the force of the wind coming across the open water of the big lake. We should have heeded the advice Bill Hansen offered on the back of his map: "Use your good judgment on Brule Lake. Its size, shape, and orientation all contribute to making Brule hazardous on windy days. If in doubt, wait for the wind to abate before making your crossing."

We didn't.

Putting all our strength into every stroke, we fought two types of waves simultaneously: rollers, with their curling walls and troughs, and haystacks,

which appeared from nowhere and jumped vertically into the air. As the person in the stern, it was my responsibility to steer, and my one thought was to keep the bow pointed into the waves. Some of the rollers were so tall that they broke over the bow of the canoe, and some of the troughs were so deep that Dad would pause with his paddle in midair until he could reach water. Having made painfully slow progress for our effort, we pulled over to the north shore, not exhausted exactly but tuckered out. As we stood there resting our aching muscles, we watched two people in a canoe fighting to make headway into the buffeting wind. Leaning forward into the spray, they gained ever so slowly on the waves. After twenty minutes or so, their progress stopped. For a brief time, they held even. Then they began to drift backward. Finally they gave up, turned abruptly in the wind and, within moments, disappeared in the direction of the south shore.

Now rested, Dad and I set out once again. Staying close to shore to avoid the brunt of the wind, we searched for the portage to Mulligan. According to Bill Hansen's map, it was on the east side of the peninsula, but when we finally rounded the point and searched the shoreline, we couldn't find it. On a hunch, we reversed directions. Now with the wind propelling us from behind, we surfed with the waves. Roller-coasting from crests to troughs, the canoe wanted to turn sideways, and we fought to keep it straight. We rounded the tip of the peninsula for the second time and searched the west side. There we found what we had been looking for: a small opening in the trees. We had paddled by without seeing it—no surprise since we had been intent on not capsizing. (The next time I saw Bill, I mentioned the error on his map. His response is one I often think of as I ponder the meaning of wilderness and the significance of the Boundary Waters. "I don't know," he said. "There's something wrong with a map of the Boundary Waters that is completely accurate.")

When we arrived on Cherokee Lake a few days later, I pulled out Bill's map to see what he had to say. "Cherokee offers some of the finest campsites in the BWCA," he writes, and he invites the traveler to "see if you can still see the after-effects of the famous 1936 Cherokee fire." He also describes Cherokee Lake as "renowned for its beauty" and points out that "the famous surveyor, outfitter, guide, and storyteller" Bill Magie "claimed Cherokee as his personal favorite in all of canoe country."

As we pushed off from the portage and paddled out among the islands and steep shorelines, I could see why. Dad and I paddled around this stunningly beautiful lake until we found a campsite on the north side of the

northernmost island. It wasn't the best site on the lake, but it felt cozy. There was only one problem.

As we were cooking dinner, we noticed an occasional critter scampering around the fire grate. No big deal, we thought. Mice tend to hang out near fire grates, where they clean up crumbs and food scraps. And then a few more appeared. They seemed unusually bold, and their apparent lack of fear surprised us, but still we didn't give them much thought. During cleanup, which we began around dusk, more than a few appeared. Now there were dozens. One darted across Dad's foot. After cleanup, we hung the food pack from a rope in a tree, as we always do at night. But when I shined my flashlight on the pack, I saw a mouse scampering up the rope like a rat dashing aboard a ship in harbor. That's when we knew we had problems. The mice wouldn't eat all of our food in one night, but they could certainly chew up our pack and make its contents unappetizing.

Weighing the relative risks of having our food fouled by the present enemy, the mice, or by a more remote threat, a bear that wouldn't mind a little swim from the mainland to reach us, we decided to deal with the present enemy. We talked over how we might protect our food and came up with a novel solution.

We lowered the food pack and loaded it into the canoe. Then I paddled across a narrow channel to a small island just north of us. I tied one end of a rope to the bow of the canoe and looped the other end around a tree on the small island. On the main island, we wrapped the rope around another tree and then secured the end of the rope to the stern, completing our loop. Pulling one end of the rope, we positioned the canoe in the middle of the channel. To prevent the mice from scampering across the rope to the canoe, we left some slack in the line so that it dipped under water on either side of the canoe. The night was still, and we hoped no wind would push our canoe from its safe harbor.

By now it was completely dark, and the site was teeming with hundreds, if not thousands, of furry critters. Apparently having called for reinforcements, they were crisscrossing our campsite in hordes, mounting their silent ambushes from all directions. Then, as suddenly as they had appeared, they vanished into the darkness. Forgoing our usual quiet time by the campfire, we dived for our tent, quickly zipping it behind us. We knew we were in no danger, but trying to go to sleep with the soft drumbeat of innumerable little feet scurrying over the nylon just above our heads was a challenge. Neither Dad nor I have a particular aversion to mice, but we both have one word for the experience: creepy.

The next morning we were pleased to find our food and canoe undisturbed. No mice had penetrated our defenses, and no bear had swum out to our island for a midnight snack. Still, the experience was unpleasant. It was the only time I have encountered such an infestation. I hope it will be my last.

Our 1982 trip was also memorable in the broader sweep of history. That year, we lost four people who figured prominently in the history of the Boundary Waters.

On January 13, Sigurd Olson died after he suffered a heart attack while snowshoeing with his wife, Elizabeth, near their home in Ely. He was eighty-two. Sig was a canoe outfitter, guide, educator, conservationist and wilderness advocate who worked to save the Boundary Waters from development. Fifteen years younger than Ernest Oberholtzer, Sig assumed leadership of the Minnesota environmental movement, serving as president of the National Parks Association and president of the Wilderness Society. He was an eloquent and outspoken advocate of wilderness values. Unlike Ober, who never managed to write the two books he had dreamed of writing—one on Ojibwe myths and language, the other on his historic Hudson Bay trip with his Indian guide Billy Magee—Sig published nine books and more than one hundred articles. In *The Life of Sigurd F. Olson: A Wilderness Within*, David Backes describes the three books he considers "most important":

> Reflections from the North Country, *which best describes his spiritual beliefs;* The Singing Wilderness, *which contains the most consistently poetic writing and best captures his land aesthetic; and* Listening Point, *which best illustrates the land ethic of a man who believed that one could hold true to ideals without being an ideologue.*

On February 5, 1982, less than one month after Sig's death, Calvin Rutstrum died at the age of eighty-six. A conservationist who worked with his friend Sig to restrict airplane travel above the Boundary Waters, Calvin grew up in the Twin Cities. As a boy, he would pay a nickel to take the trolley line to the city limits—or more often hike the distance to save the nickel. From there, he would set out with his backpack "on a secluded and picturesque, motor-car-free, country road, which most often was but two meandering ruts through the forest." In *Once Upon a Wilderness*, he describes how he found what he was looking for in the undeveloped countryside just outside the city limits:

You could plan to be on the bank of some crystal-clear stream or on the shore of a clear-water lake before nightfall, to set up a small tent and cook your supper over a tiny wood fire. No outboard motor stirred up the water or broke the magic stillness; no plane roared overhead. A deep serenity came over the evening camp. An owl hooted, a whippoorwill called in his typical repetitive manner, and sleep was allowed to be couched in sweet repose.

In his search for a simple, meaningful life, Calvin ended up spending his adult years in a cabin in Cloud Bay, Ontario, where he wrote most of his fifteen books on nature, canoeing and wilderness values. His first book, *The Way of the Wilderness*, published in 1946, is considered a classic by many canoeists.

Then, on March 4, 1982, one month after Calvin's death, Bill Magie died. He was seventy-nine. A lifelong advocate of wilderness protection who was not above poaching an occasional deer or moose and who once helped run a load of scotch across the border from Canada during Prohibition, Bill was known for his sense of humor and a storytelling style that blurred fact and fiction. He was a commercial airline pilot early in the industry's history (with two licenses signed by Orville Wright), and he worked as an engineer in some of the first surveys of the Minnesota-Ontario area, where he "traveled all over the place in both summer and winter, hauling supplies, running levels, doing ground control for the aerial photos, and gauging rivers," as he told Dave Olesen, who recorded and edited his stories. In the 1930s, Bill worked as camp superintendent for the Civilian Conservation Corps. In 1949, Bill, Frank Robertson and other conservationists founded Friends of the Wilderness to represent organizations that supported a ban on airplanes over the Boundary Waters. In his later years, he worked as a canoe guide for Bill Rom's Canoe Country Outfitters, leading groups in the area around Ely.

Then, sometime in August 1982, just a few months after Bill died, Benny Ambrose died, probably of a heart attack. Benny had moved north from Iowa to prospect for gold after the First World War, and he lived alone in a one-room cabin on Ottertrack Lake for more than sixty years. At the time of his death, he was eighty-three, or maybe eighty-six. His birth date is uncertain, and because he died alone at his cabin, the exact date of his death is also unknown. Forest Service rangers found his body next to the burned remains of his summer kitchen. The fire may have started after he died of a heart attack or stroke, or his cabin may have caught fire while he was sleeping, and he perished in the flames. Whichever came first, according

to Bob Jacobsen, a Department of Natural Resources (DNR) conservation officer, as quoted by Nick Coleman in the *Minneapolis Star Tribune*, "He lived the way he wanted to and he went the way he wanted to, I imagine. He told me if I ever come up missing don't even bother to look for me. If I'm dead in the woods someplace—that's where I want to be."

Regardless of the exact date of his death, Benny was the second to last permanent resident of the Boundary Waters. The last was Dorothy Molter, who died four years later, in 1986, at age seventy-nine. Since 1974, she and Benny had been the last two people living in the Boundary Waters. Dorothy died in her log cabin on Isle of Pines on Knife Lake, eleven miles southeast of Benny's cabin, where she had lived for fifty-six years. A familiar face to thousands of canoeists, she was known as the "Root Beer Lady" because of the homemade brew she made and sold to people who stopped by to see her. My friend Tom, a member of my men's group, was one of those visitors. Like most people, he was impressed by the beauty and simplicity of her life in the woods, although he gave a negative review of her root beer. "It really wasn't that good," he once confided to me. Another friend took issue with his review when I mentioned it to him. "Believe me," he said, "if you tasted Dorothy's root beer toward the end of a ten-day trip with Outward Bound, it was good."

So counting Dorothy, from 1982 to 1986, we lost five people who lived in or near the Boundary Waters. In a way, their deaths represent the end of an era, the passing of a generation of people whose lives were associated with wilderness living. Decades after the last native inhabitants had moved away (or had been forcibly moved away), these five people enjoyed a region that, despite plans to develop it, despite two periods of extensive logging and despite the might of an economic system that measured the value of things in dollars and cents, had retained its wilderness character with relatively few rules and regulations.

Things are different today. Now when I visit the Boundary Waters, I need to apply for a permit, which costs twenty-two dollars, plus twelve dollars for each person in my party. I can't travel in groups of more than ten people, and I can't have more than four canoes in my group. I can't sink my bottles and cans to the bottom of the lake or stash them in piles back in the woods, as was commonly done for decades. I can't even bring my food and drink in cans or glass containers. I can't camp anywhere I'd like to but only at designed campsites. I can't cut green wood or gather driftwood. I can't peel the bark from birch trees to start my fires. I can't burn my garbage. And I

can't use soap to wash my dishes—or my hair—in the lake or anywhere near it. In *A Wonderful Country: The Quetico-Superior Stories of Bill Magie*, Magie expressed his exasperation with all the rules. "I don't hardly go into the BWCA anymore," he declared. "There's so damn many new regulations. Half of 'em aren't needed."

Greg Breining once asked Sig Olson "whether sometimes the designation of an area such as the Boundary Waters defeats its purpose by inviting ever more people." In *Boundary Waters*, a book Breining did with photographer Jerry Stebbins, Breining says that Sig "had thought about the problem often," and "his answer was prompt and firm":

> *Once you set the area aside you can work out the problem, regulate the use, later...God, I hate to use that word "regulation," but if the area wasn't loved to death, if it wasn't protected, you'd have logging, you'd have mining. God knows what you'd have.*

I guess that's my answer as well. I can sum it up in one word: balance. We need to strike the right balance between freedom and responsibility. Boundary Waters campsites are like heavily used motel rooms—without the maids. If some 200,000 visitors are camping at approximately two thousand designated campsites, as many as 100 people may camp on each site every summer, perhaps more on popular sites. A "pristine" environment in such a heavily traveled area is no longer a realistic or attainable goal. We need common-sense rules and regulations. As objectionable as they are to people who remember the old days when relatively few visitors were leaving their mark on the land, and as offensive as they are to those who live nearby and feel their access has been limited by outsiders and city folk who want to make the Boundary Waters their private playground, without those regulations, we would love the area to death.

On the last evening of our 1982 trip, I was sitting in the canoe with Dad, not fishing and not paddling to go anywhere in particular, just drifting with the breeze. The evening sun was warm and comforting on our faces. I had been preoccupied with a conflict I was having at work. I took a long breath, drawing the sweet Boundary Waters air into my lungs and something changed inside me. The tension I had been holding for months was gone. I was ready to reengage with the challenges and frustrations of my everyday existence, ready to recommit myself to succeeding with whatever I was trying to accomplish in life.

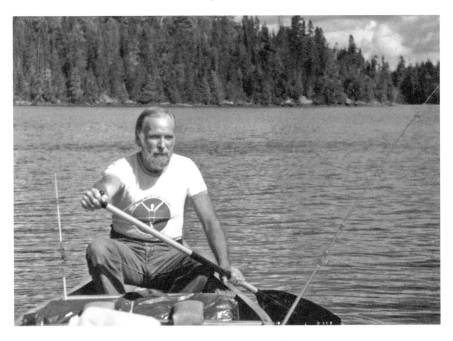

Steve's dad looking handsome in the stern in 1983.

The next morning, Dad and I awoke to a lake "held captive by nets of white fog," in the words of Florence Page Jaques. The world was hushed and calm. Inspired by the spirit of the morning, we paddled slowly, reverently, so as not to disturb the silence. "The movement of a canoe is like a reed in the wind," Sig Olson wrote in *The Singing Wilderness*. "Silence is part of it, and the sounds of lapping water, bird songs, and wind in the trees. It is part of the medium through which it floats, the sky, the water, the shores." As Dad and I glided across perfectly still water, the sun began to penetrate the white shroud. At that moment, life seemed simple and elemental. Its only ingredients were the sun and the fog, the gurgle of our paddles stroking the water and the gentle glide of our canoe. But for me it was the beginning of a glorious new day. I was ready to go home.

Just Dad and Me, the Gunflint Trail, More Historical Figures and My Men's Group

W hen you move away from the place where you grew up, you don't get many opportunities to introduce your father to your adult friends, but that opportunity came to me in 1984. For more than thirty years, my men's group has met monthly. We joke around a lot and often behave like teenage boys, even in public, but our purpose in gathering is to talk about the deeper issues in life—not just sports and politics and the events of the day, but our spiritual lives, relationships, families, careers, aspirations, disappointments and dreams. In recent years, our topics have shifted to health, retirement plans and the loss of loved ones.

This year, Dad and I combined our annual canoe trip with the first of many trips I've taken with my men's group. Dad and I put in at Norwester Lodge on Poplar with just the two of us, and then on Friday we looped back to rendezvous with the guys, who were out just for the weekend. It was the second of four times Dad and I flew to Devil's Track Lake in his Cessna 172, and the first time we departed from the Gunflint Trail rather than from the Sawbill Trail.

The Gunflint Trail takes its name from Gunflint Lake, a body of water known to the French fur traders as Lac des Pierres à Fusil because they used the flint-like rock found along its shore in their flintlock rifles. It crosses the Laurentian Divide at Birch Lake, with water on one side flowing southeastward to Lake Superior and water to the west flowing northward to Hudson Bay. The first part of the trail was laid out from Grand Marais to the

eastern end of Rove Lake, where a trading post was established and operated by Henry Mayhew in the 1870s and 1880s. It followed an overland footpath that had been used by the Ojibwe for hundreds of years. About 1891–93, the trail was extended from Hungry Jack Lake to Poplar Lake, Gunflint Lake and the Cross River. Over the decades, it was improved from a primitive dirt road to a gravel road, and it was widened for horse-drawn wagons and eventually for automobiles. Today, the Gunflint Trail is a sixty-three-mile paved highway with a fifty-mile-an-hour speed limit providing access to numerous resorts and entry points. Although it has a less primitive feel to it than the Sawbill Trail, it provides access to some beautiful lakes and resorts.

On our first night out, Dad and I camped on an open rocky point on the east bay of Caribou in fog. It was so thick that it completely enveloped the surrounding islands and shorelines, reducing our world to a quiet, white space whose circumference was pierced now and then by the sudden wail of a loon. In the morning, we packed our lunch, towels and fishing gear and took the tough portage to Winchell for a day trip. The next day, we moved on. I know where we stayed the next two nights—on the north shore peninsula on the west bay of a lake that was west of Gaskin and north of Winchell—but I'm not certain of the lake's name. It's called "Omega" on my W.A. Fisher map, but Bill Hansen identifies it as "Ogema" on his map, noting that the lake is commonly mislabeled on other maps. "Ogema," Bill explains, is the Ojibwe word for "beaver." According to other sources, however, "amik" is the Ojibwe word for "beaver," and "Ogima" is the word for "chief." Whether chief, beaver or *W*-shaped lake resembling the lower-case omega of the Greek alphabet, it was a lovely place to camp.

From that lake, we took a second day trip, paddling north to Phalanx and then to the west end of Finn, where we reached that magical point in a canoe trip—our most remote location. The next day, we traveled from Whatever-the-Name-of-That-Lake-Is to Hensen, Pillsbery, Allen and Horseshoe, where we saw two moose—a cow and a calf—on the north shore just after the portage. We stopped for lunch on the island on the north bay of Horseshoe and camped on Caribou on the middle campsite of the three campsites on the north shore.

As I closed my eyes that night, I thought about the people who had worked so hard to protect and preserve this "maze of bewildering beauty." In 1922, Arthur Carhart, a landscape architect hired by the U.S. Forest Service, had proposed a plan to preserve the border lakes region as a canoeing area. He called for a fully protected core area and limited, controlled development in the outer areas. Although his plan was not implemented, it stands as our country's first proposal for managing and protecting a wilderness area.

A cow and a calf on Horseshoe Lake in 1984, the year they canoed with the men's group.

The next year, at the first of many conferences to resolve differences regarding management of the Superior National Forest, Will Dilg, founder and first president of the Izaak Walton League of America, made an impassioned plea opposing a U.S. Forest Service plan to bisect the core of the "roadless area" with a road linking Ely and the Gunflint Trail. Today, it's hard to imagine a road cutting right through the heart of this precious region, but that's what some people wanted. More than that, county governments and local chambers of commerce adopted as their slogan "A Road to Every Lake." To oppose construction of these roads, the Superior National Forest Recreation Association was organized, with Paul Riis as its head.

Some of the people advocating wilderness protection demonstrated extraordinary courage in standing up to friends and neighbors who favored development. In 1949, Forest Ranger Bill Trygg faced down angry opponents when the Ely Rod and Gun Club met and reconfirmed its support for an airspace reservation over the Boundary Waters. Later that night, a homemade bomb exploded outside the home of Bill Rom, an outfitter who supported the ban. Fortunately, no one was injured, and the bomb caused little damage. In 1976, seven years before our canoe trip, the Friends of the Boundary Waters Wilderness was formed, with Miron (Bud) Heinselman

as its chair in opposition to a bill introduced by Representative James Oberstar. Like Carhart's proposal, Oberstar's plan was two-tiered. It would have maintained wilderness designation for some of the Boundary Waters, but it also would have removed land to create a "recreational area," where logging and mechanized travel would be permitted. In response, the Friends was organized to advocate for greater protection of the Boundary Waters and to promote "the biological, intrinsic, aesthetic, economic, scientific, and spiritual values of wilderness." Other founding members included Fern Arpi, Chuck Dayton, Dan Engstrom, Dick Flint, Jan Green, Herb Johnson, Jack Mauritz, Steve Payne, Chuck Stoddard, Paul Toren, Herb Wright and Dick Wyman.

In 1977, an effigy representing Sig Olson and Bud Heinselman was hung outside the Ely High School while approximately one thousand people gathered in town for a hearing of Congressman Don Fraser's bill, which would become the Boundary Waters Canoe Area Wilderness Act of 1978. Amid boos and catcalls, Olson spoke in favor of Fraser's bill.

"This is the most beautiful lake country on the continent," he declared in his deep, resonant voice. "We can afford to cherish and protect it. Some places should be preserved from development of exploitation for they satisfy a human need for solace, belonging and perspective. In the end, we turn to nature in a frenzied chaotic world, there to find silence—oneness—wholeness—spiritual release."

I was happy to have Dad to myself for the first part of our trip, although I don't remember any deep conversations. Most of our talk consisted of observations of the trip, such as "Hey, there's an eagle" or "The portage is at the end of this next bay if I'm reading the map correctly." In *Cold Comfort: Life at the Top of the Map*, Barton Sutter talks about "a natural kind of dual solitude":

> *It's the sort of steady state that sometimes develops in a lucky marriage, in which a pair can be alone together without feeling lonesome, in which much is understood without speech, in which silences are calm, deep, and satisfying. Some such quiet understanding develops quickly between like-minded partners out on the canoe trails: If you gather firewood, I'll fetch the water. If you cook supper, I'll do the dishes. You paddle on the left, I'll paddle on the right. There's no need to negotiate…or even to speak.*

That's how it was for us. Even if Dad and I didn't talk much, just spending time with him was pleasant and worthwhile.

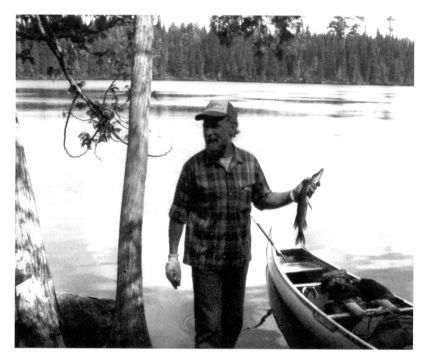

Steve's dad with a northern in 1984.

Steve and his dad in 1984.

One member of the men's group capsized in 1984.

Looping back to Poplar, we met the men's group at Trail Center Lodge. After introductions and the chaos of sorting and loading the gear of a large group into canoes, we paddled across Poplar, Caribou and the lower west arm of Horseshoe to an island campsite on the east end of Gaskin. I was pleasantly surprised to learn I had underestimated the camping and canoeing skills of the men's group. Two members of our group were especially experienced. Another provided a memorable incident when he capsized his canoe near shore, to everyone's amusement. Dad still laughs when he talks about it.

Something about seeing Dad enjoy the company of my friends—and seeing them enjoy his—made a deep impression on me. The members of my men's group have become my family away from my Cincinnati home. Without them, I doubt I would feel as connected to Minneapolis as I do. Most of them grew up here, and their childhood stories of playing in the woods by the Minnehaha Creek and climbing the mounds of dirt when I-35 was under construction have become entwined with memories of my own childhood. It was as though my past and my present—and in a way, my future—had been bound together. Since then, whenever I talk with Dad about my men's group, he knows who I'm talking about and how they fit into my life.

7
ONE DRAMATIC RESCUE, PEACE AND SOLITUDE ON SOUTH TEMPERANCE AND A GOOD TALK ON RETIREMENT CAMPSITE

For the past two years, we had traveled north from Minneapolis not by car but by single-prop airplane, as we did this year, 1985. When he was eighteen, Dad had volunteered for the Army Air Corps during the Second World War and had flown a lumbering C-47 transport plane over "the Hump" of the eastern Himalayan Mountains between India and China. Ever since the war, he had dreamed of flying again. Now, at fifty-eight, he was doing it. He flew his Cessna 172 from Cincinnati to Flying Cloud Airport, southwest of Minneapolis, and from there to the Skyport Lodge at Devil's Track Lake on the North Shore.

This year, my son Eddy was with us. It was his second trip to the Boundary Waters. He took his first trip in 1983, when he was four years old. We were picked up by Cindy Hansen, who told us that she and Bill had gotten married that year. The three of us paddled north on Sawbill past the narrows to the same campsite where Dad, Larry, Tim and I had stayed in 1979. As we were making camp, a bear walked onto our site, but I managed to chase it away before it ripped into our food pack.[†]

† In 1991, the Department of Natural Resources estimated there were between fourteen and seventeen thousand black bears in Minnesota. In 2011, their population is estimated to be twenty thousand. Like the eastern timber wolf, they are expanding their range southward and into the farmlands of northwestern Minnesota.

After Dad and Eddy had gone to bed, I stood on the rock point in the moonlight. The moon was nearly full, the night clear and the trees and rocks on the far shore plainly visible in the soft white light. As I gazed at the ghostly beauty around me, I wondered how many people had contemplated the same view during the ten thousand years since the retreat of the most recent glacier. How many Native American hunters had hauled game across these routes, how many lovers had embraced in the moonlight and how many children had played by these rocky shores? How many explorers, French fur trappers, lumberjacks, recreational campers and anglers had there been? It's humbling to think that one human's life span is inconsequential in the sweep of history, minuscule in the limitless expanse of time and space as indexed from this granite point. As Kate Crowley and Mike Link observe in *Boundary Waters Canoe Area Wilderness*, "Humility is easy when the rock you sit on predates all forms of life." In his story "In a Smaller World," published in the July 1989 edition of *Canoe Magazine*, Douglas Wood connects the past and the future when he steps away from his companions beside the campfire:

> *I went down to the rock ledge where we'd stored the canoes. They lay there like four sleek shadows, reminders of the small size and vulnerability of our group—and of groups like us throughout human history, who had risked everything to explore and travel the mysterious world around them. Now that search has led to the stars, to the realm of the meteors.*

The next day, we stopped for lunch on Ada. As we were sitting on the steep shore of a little island, Eddy began sliding, and into the lake he went. Before I realized what was happening, Dad went in after him and handed him up to me. No one was injured, but the incident looms as a dramatic rescue in our family history.

After Dad and Eddy had changed into dry clothes, we traveled on to Cherokee and from there to Sitka and then to North Temperance. When we arrived at the end of the portage to South Temperance, we liked the look of the lake. Its islands and tall encircling pines gave it a cozy, secure feel. While we were loading our canoe, two men paddled toward us. One of them, Carl, a lean man wearing a broad-brimmed hat, looked to be in his late seventies. He told us he had trapped the area forty years ago. We asked him how the wilderness today compared to then.

"It looks pretty good," he said. "Things haven't changed much."

Not everyone would offer such a positive review. When Dave Olesen interviewed Bill Magie in the late 1970s, Magie complained:

> *Years ago, you never had to worry about a campsite. You never looked for a campsite till four-thirty in the afternoon. At five o'clock you'd go ashore, pitch your tent, start a fire, hang the coffee pot on, peel a few potatoes, hang them over the fire, jump in the canoe, and go out and get a fish for supper. But those days are gone forever. Yes, sir. Now you want to start lookin' for a campsite right after lunch. Otherwise, they're all filled up.*

Magie died in 1982 at age seventy-nine, so he and Carl were more or less contemporaries. Both had known an undeveloped wilderness intimately, but whereas one seemed pleased that things had been so well preserved, the other was disturbed by all the changes. I appreciate both points of view, though like Carl I'm more inclined to see the glass as half full rather than half empty. The Boundary Waters isn't everything I'd like it to be. Like Ober, I wish 14,500 square miles had been preserved. But I'm thankful for what we have.

We paddled over to the campsite to the right of the portage. Soon after we had settled in, a bank of clouds rolled in.

"Looks like a cold front," Dad said. "Could be with us for several days."

After dinner, Eddy and I went out for a paddle. As we circled the large island on the west end of the lake, we could smell moisture in the air. The light faded from the sky, and bats appeared, silent creatures of the night flitting just above the surface, darting toward us and then veering off just shy of our heads. We rounded the tip of the island, and it started misting. Soon, the mist turned to drizzle. As we headed back toward camp, Eddy asked me how I was able to find our site in the dark.

"By the shape of the lake," I said, "and the contour of the shoreline." I told him that, for me, finding my way back to a campsite in the dark is easier than finding my car in a parking lot in broad daylight. "You just have to pay attention to your surroundings," I said. "The shoreline tells the story."

When Eddy and I arrived at our campsite, we found Dad standing near the food pack, awaiting our return. He was eager for me to help him hoist the pack and get to bed. In our absence, he had tied one end of a long rope to a rock and tossed it over a high horizontal branch of a white pine just off our campsite. Hoisting the pack was a two-person operation, with me pulling and Dad pushing the bottom of the pack with a paddle. After the pack was aloft the

recommended twelve feet from the ground and six feet from the nearest tree or branch, I looped the end of the rope around a tree trunk about thirty feet from the supporting branch. With Dad pressing the loops into the rough bark with his palms to prevent the rope from slipping, I cinched it taut by looping the end around the trunk and back over the rope and pulling tight, each time taking up another inch of slack, a technique I learned from my scoutmaster, Mac. Then I secured the loose end with two half-hitches, and we were done.

For most of the night, it rained, an even drizzle pattering gently on the nylon above our heads. As I fell asleep to a sound I love, I counted myself a lucky man.

The next day, the sky cleared. After breakfast, we filled our pots with lake water and placed them in the sun to warm, then headed off in the canoe to explore and do some fishing. When we returned a few hours later, I was eager for the pleasure that awaited me. We stripped down and dived into the cold lake. Then we grabbed the pots we had left in the sun, soaped up and took turns pouring the sun-warmed water over our heads and shoulders. We had walked back in the woods, well away from shore, because soap—even "biodegradable" soap—promotes algae growth in the water. Many submerged rocks next to campsites bear the telltale green coating from campers having washed their dishes in or near the lake or having lathered up their bodies and hair before jumping in.

After bathing, the three of us headed over to the mound of boulders that separates South Temperance from Brule. Next to the boulders, we entered the slow current of a clear-water pool. We stopped paddling and drifted. Below us, dark green weeds dipped and swayed in an elegant slow-motion dance.

We were far enough along in our trip, and sufficiently distant from civilization, to have fallen into a natural routine of paddling, making camp, fixing dinner, watching the sun set, sitting by the fire and going to bed. "I love the pace and rhythm of a day in the Boundary Waters," Douglas Wood writes in *Fawn Island*. Like Wood, we were experiencing "the strange power of a paddling trip to distill and clarify":

> *Days that are too often fragmented and incoherent begin to come into focus, as under a lens. There's a beginning, middle, and end to a day, all connected by a path—a path of waters. Islands and headlands pass, with plenty of time for the mind to take them in. Wildlife and plant life are observed, weather noted. It's not fast, it's not exciting, but in its very simplicity it allows for the coherent experiencing of one's day. Of one's life.*

That evening, we did one of my favorite things to do in the Boundary Waters—we stretched out on a smooth, flat rock by the shore and watched the sun drop behind the trees and the light fade from the sky. We watched the entire process, from beginning to end, hardly speaking, giving ourselves over to the natural rhythm of the day, heeding the advice of Paul Gruchow in *Boundary Waters: The Grace of the Wild*:

> *Assisting the sun on its daily journey over the western horizon is one of the necessary labors of any journey into a wilderness. The work requires close attention. If you are with a companion, the conversation must be hushed and never too urgent. It will not do to argue or joke the sun away. Patience is a virtue diligently to be practiced at all times, but especially at evening; the sun will not be hurried. It is reticent about crossing the horizon. When it reaches that threshold, it takes the pause that every dramatist knows well, the brief sigh of silence, before it makes its exit and the curtain falls.*

"Then especially," Gruchow warns, "one must not break the mood with unseemly chatter or busyness of any kind."

After the sun had completed its journey, I sat with Eddy by the fire and read a story to him about cowboys on the Chisholm Trail traveling one thousand miles from Texas to Abilene, Kansas. When Dad joined us, he said he didn't often take time to just sit and relax. This is Dad's last week of work. Officially, he's still on the job, but he's counting this week as vacation. He's not going back. So here he is, spending his last week of work with his son and grandson in the Boundary Waters. As we talked, I realized that Dad and I were having one of the least-hurried conversations we had ever had in the Boundary Waters—or maybe anywhere.

"Now that you're retired," I said, "you can take the time to do what we were doing today. You can do this every day of your life if you want to."

Yes, he agreed, he could. He said he planned to take more time for things. We talked about his career and the things he loved to do—flying, playing golf, running, sailing, country line dancing, house boating, snorkeling, playing bridge. I asked him how it felt to be leaving behind an occupation that had required so much labor and had claimed so many hours of his life.

"It feels good," he said. "I'm looking forward to retirement."

He had much to be proud of. In 1951, thirty-four years earlier, Dad had begun working at the General Electric plant in Evandale, Ohio, when jet engine technology was in its infancy. In 1977, he was awarded the William Badger

award as the outstanding material engineer. He holds one patent for "the HIP densification of castings to remove internal shrinkage in castings" (his words, not mine). He managed as many as two hundred engineers and support people.

As we sat talking by the lake on that warm summer evening, the sun set and the moon rose over the hill. In the lingering light, a jet passed high above us, leaving a squiggly white contrail next to the moon. When we paused in our conversation, we could barely hear the whisper of its engine. I was pleased that the sound was faint rather than loud and intrusive. We have Sig Olson, Charles S. Kelly, Frank Hubachek, Bill Magie and other conservationists to thank for that. It was largely through their efforts that President Truman signed that 1949 executive order creating an "airspace reservation" that bans private flights below the altitude of four thousand feet above sea level.

After a moment, Dad said, "That plane is more than six miles up."

It was far away, far enough that it seemed to inhabit a realm apart from our own. Its intrusion into our wilderness world seemed insignificant.

8
LAKE TWO FIRE, TABLE ROCK, INDIAN NAMES AND THE SONG OF A LOON

The next year, 1986, Dad, Eddy and I were approaching the airstrip at Devil's Track Lake at treetop level when the plane suddenly lurched. In an instant, we were twenty feet closer to the ground. My heart in my stomach, I watched Dad struggle to keep the plane under control. When the wheels touched the ground, the plane swerved sharply, then straightened out.

"What was that?" I asked breathlessly.

"A wind shear," Dad said. "At tree level, we hit a crosswind. It was probably generated by wind coming across the lake. When that happens, the important thing is not to lose air speed."

I asked him if he had to pull up to compensate.

"No, I kept coming down," he said, "but I maintained air speed."

When we arrived at the outfitters and walked back to the dome where they keep their rental equipment, Frank Hansen gave us a warm greeting. A little while later, Bill said hello. Both father and son have dark hair. Frank can be gruff, but you can tell he's a nice man. I've never seen Bill be anything but nice.

We put in on Kawishiwi Lake and paddled to Square, where we camped on the south campsite. After our steak and potato dinner and our runny butterscotch pudding dessert, Dad handed me a soapy cup to dip in the hot rinse water.

"You know," he said, "sometimes the landings you have to work hardest at turn out to be your most professional."

It wasn't the first time I felt reassured by his military training. By the time Dad had begun pilot training school, the Army Air Corps had acquired most of the pilots it needed for the war, so the washout rate for new pilots was extremely high. Following a nighttime training flight in a Vultee Vibrator, Dad told his instructor he wasn't ready for a solo flight. His refusal to fly put him one lesson behind his buddies. The following evening, on February 20, 1943, Dad was given an elimination ride. If he blew it, he was out. Starting before dusk and going into the night, he shot touch-and-go landings, first with his instructor and then alone. Because he was the only cadet using landing lights, his classmates knew each time he was attempting a landing. That night, he did forty perfect touch-and-goes, to the cheers of his buddies. He refers to those touch-and-goes as "the best forty landings I've ever done in my life." I've always been proud of him for making the cut and for serving his country with honor. Now I was thankful for his accomplishment in a new way.

After Dad and Eddy went to bed, I sat by the fire writing in my—whatever it was I write in. I didn't know if I should call it a diary, a journal or a log. Maybe a Sawbill log.

Earlier this year, from May 29 to June 24, a small island on Lake Two was set on fire by a careless camper, resulting in a major forest fire. For the first time in seventy-six years, a significant fire in the Boundary Waters was allowed to burn without intervention by the U.S. Forest Service. The decision to let the fire burn marks the beginning of the end of our fire-suppression period, a period dating from 1910, when the official policy was to suppress all forest fires under the mistaken notion that forests needed to be protected from this naturally occurring phenomenon. We now know that this policy was not good for our forests, which depend on periodic fires to clear the understory so that they can regenerate.

The next day, on the portage between Koma and Malberg, we stopped by the waterfalls for a pleasant rest. Dad swam, while Eddy waded and I stretched out in the sun. I closed my eyes and listened to the comforting drone of the water. As anyone who has traveled this route knows, perched improbably at the mouth of the rapids, where the stream empties into Malberg, is a large boulder. It sits alone—a glacial erratic, as it's called—either left by a retreating glacier or placed by the hand of God, depending on your viewpoint. At home, I often return to this spot in my mind, especially

The boulder by the stream leading into Malberg Lake.

in the dead of winter, when my yard is buried under two feet of snow. If this special little place were ever altered or developed, I would feel a personal loss, even if I were never to come here again. Just knowing the Boundary Waters is here, protected and undeveloped, provides solace to tens of thousands of people. Just knowing that wilderness still exists on this planet is important to millions, if not billions, of people around the world, even to those who will never see or experience it.

I think we as a people do understand the importance of the natural order of things. We do appreciate the beauty and significance of an unaltered landscape, and something deep within us craves to be connected to it. And yet, we also have this impulse to alter it, to somehow improve and own it and certainly to profit from it. Creating the National Park System for all to enjoy was one of our country's wisest decisions, and yet we can be so boneheaded and foolish in our disregard for the natural order of things. When I say "we," I mean modern Americans, not traditional Native Americans.

Though fierce when defending their territory from encroachment by neighboring tribes and often cruel in their treatment of prisoners, the Indians were gentle with the Earth. It's not that they lived without impact

on the natural environment, but they understood their place within it, and they felt a deep connection between the physical and spiritual worlds. To treat an animal disrespectfully was to dishonor a relative. When an animal was killed for food, a prayer was offered thanking the animal for sacrificing its life so that the tribe might live. Not all whites were so respectful, nor were they so humble regarding their place in the natural scheme of things. Some even believed they had the right to do whatever they liked with the natural world.

Perhaps the stupidest thing ever done in the Boundary Waters, though by no means the most harmful, was an attempt to remove Table Rock from its natural setting and put it on display in a museum. A large, naturally flat rock resting on smaller rocks on the shore of Crooked Lake, Table Rock was mentioned by the early white explorers Alexander MacKenzie and La Verendrye as an important meeting place where Indians brought their furs to trade with whites. Table Rock is part of the history, legend and spirit of the Boundary Waters. In *A Wonderful Country*, Bill Magie provides this version of what happened to it:

> *That Table Rock is cracked now—that used to be one great big rock. Some damned fool outfit was gonna move it, take it to St. Paul and put it in the Historical Society. They hooked two blocks and tackle on it. (I wasn't there, but I heard about it.) They moved it about eight feet and it cracked off. They left it, they never tried any more.*

If Magie's recollection of events is accurate, the damage was done on the misguided assumption that historical artifacts can be removed from their locale without loss, as though connection to place has no meaning.

I enjoyed visiting our old campsite on Malberg, although it looked more worn and eroded than I remembered from when we camped there in 1978. I was pleased to see that the smallish rock just off shore was where I left it after stretching out on it to watch the sunset. I found its presence reassuring. It has stood in this same spot for some ten thousand years, and it will stand here long after I'm gone. Countless visitors like me will lie back on it to watch the sun set, supported by its warm embrace. I hope no one ever tries to move it.

The next day, we traveled down the Lady Chain to Hazel, and from there we took a day trip down the beautiful narrows of Knight, where the wilderness seems so near. I love the series of lakes known as the Lady Chain,

so called because all the lakes except one in the string bear the names of women: Polly, Hazel, Knight, Phoebe, Grace, Ella and Beth. According to Bill Hansen's map, a pioneer forest ranger named Bill Mulligan named the lakes after his maiden aunts.

I wonder what Native Americans called these lakes. For the most part, we don't know, although some Ojibwe words are still used as lake names, including Nibin (summer), Bibon (winter), Wabang (tomorrow), Niswi (three), Neewin (four), Abinodji (child), Abita (half), Makwa (bear), Nabek (male bear), Andek (crow), Cacabic (waterfall), Saganaga (inland lakes), Koma (from "Goma" or "middling") and Kiskadinna (steep hill). According to Jon Nelson in "Prairie Portage—Wilderness Crossroads" (published in the summer 2002 *Boundary Waters Journal*), Basswood Lake derives from the Ojibwe name *Bassi-minan-sag*, which in English means "dried-berry lake." However, the English word "Basswood" has little to do with the original Ojibwe: "There are a variety of explanations as to how this name slowly morphed into Basswood Lake. Most people don't think the name refers to basswood trees, although a few do grow along its shores."

The original Indian names probably revealed something about the character and personalities of the lakes. In an interview with Evan Hart, and as quoted by Joe Paddock in *Keeper of the Wild*, Ober complained about a general disregard for traditional Indian names:

> Anishinabe [the name the Ojibwe call themselves] *means the real people…I think that's a nice name, Anishinabe—musical. Yes, it's a beautiful language to hear. And it hurts me to think of the scorn with which it's treated, even by some geographers. You have these beautiful names clinging to these places in the north, and then they give them some perfectly commonplace name. I think that's awful. Maybe there's some man in the legislature over there in Canada…and they name it for him. Some temporary minister of lands or forests. They use a name like Finlayson, when they already had a wonderful name like Kabetogama or Anishinabe or any of the beautiful old Indian names, you know, soft and lovely, with a significance that goes way back.*

Retaining the Indian names, as explorer Ernest Oberholtzer advocated, would have given us a history of the region that was richer, more colorful, more respectful and even more useful.

A page from Steve's log.

That night, after Eddy and Dad were asleep, I took the canoe out and paddled in the moonlight, enjoying the effortless thrust and glide of the canoe. I thought of the time eight years ago when Larry, Tim and I paddled out on Snipe, a lake about the same size as Hazel, and lay back in the canoe to watch the stars. Memory asserts itself in odd ways. Some years after that night, I began to think our starlit paddle occurred on Hazel rather than on Snipe. It became fixed in my memory that way. Then, when looking at the old map indicating our 1979 route, I realized I had it wrong in my mind, but by then it was too late. As memoirist and poet Patricia Hampl once observed, it's not what happens that counts. What counts is what has happened in your thoughts *since* what happened. Our starlit paddle may have occurred on Snipe rather than Hazel, but after so many years of thinking it happened here, one reality has overtaken another.

When I returned to camp, I beached my canoe and climbed into the tent, unzipping and zipping the door as quietly as I could. As I closed my eyes, I thought about Dad. He looks good. He says he's ten pounds heavier than last year, but he looks fit. His white beard becomes him. I think I'll grow one when mine turns pure white. After the salt-and-pepper stage.

Then a loon began its plaintive wail. The sound expanded slowly inside my head. Then, as the last note faded into the distance, I felt as though I had been transported to some place unfamiliar. I love that sound. I never get enough of it. When the song began anew, its rising notes intimate, nearby, it brought me back to a familiar setting, where I felt centered and at peace.

9

A New Used Canoe, an Old Friend, End of the Fire-Suppression Period, Pictographs on Fishdance Lake, Raging Rapids, a Wilderness Canoe Repair Shop and Alice Lake at Last

In 1987, I bought a used Alumacraft from the Sawbill Canoe Outfitters. I had sent a $100 deposit to Frank Hansen, and Bill had set one aside for me. It was in its third season. The price, $240, seemed reasonable, and having my own canoe made my commitment to taking regular trips to the Boundary Waters feel more definite. Its many scratches and dents tell the story of its voyages. Dad has something new, too: a new two-person Eureka! dome tent. It's nice—compact and light.

Following last year's Lake Two fire, a new prescribed natural fire management program was officially adopted by the U.S. Forest Service and implemented in the Boundary Waters. Rather than suppressing all fires, the new policy allows lightning-ignited fires that pose no threat to people or property to burn themselves out naturally. With this change, "the fire-suppression period" of 1911 to 1987 came to an end.

Implemented after an exceptional drought when major forest fires burned some eighty square miles south of Saganaga Lake and at the western end of the Gunflint Trail, the fire-suppression method of managing forests resulted in unintended consequences. As Miron (Bud) Heinselman explains in *The Boundary Waters Wilderness Ecosystem*, suppressing all fires interferes with a natural cycle that creates new stands of forests. It also curtails periodic elimination of the tree-killing spruce budworm and causes a buildup of dead trees in forest understories. These unnaturally high fuel loads increase

the likelihood of super hot fires that scorch the thin topsoil of the border lakes region, killing organic matter and the seeds of trees such as jack pine, black spruce and red pine, which normally reestablish themselves rapidly after fires.

Forest fires are a regularly recurring feature of the Boundary Waters ecosystem. According to Heinselman, major fires occurred in 1595, 1681, 1692, 1727, 1755–59, 1796, 1801, 1822 and 1824, creating conditions for forest regeneration. Before the unnatural disturbances of logging and fire-suppression management in the late nineteenth and twentieth centuries, this natural cycle of fire-mediated forest renewal, or "patch turnover," affected about three-quarters of the landscape of the Boundary Waters region every fifty to one hundred years, resulting in a mosaic of even-age stands. In other words, without tree-killing fires periodically wiping out vast areas of forest, you wouldn't have those lovely stands of mature red and white pine one hundred or two hundred years later.

In 1863–64, extreme drought resulted in the biggest forest fires in centuries, burning several hundred square miles, or 400,000 acres. Nearly half of the present Boundary Waters Canoe Area Wilderness burned, including 434 square miles of forest between the Isabella River and Saganaga Lake and 176 square miles of forest south of Lac La Croix. Second in size in recent history only to the 1863–64 fires, the forest fires of 1875 burned more than 300 square miles of forest in the border lakes region, affecting an area from Sawbill, Alton and Kawishiwi Lakes in the south to Alice, Ogishkemuncie, Tuscarora and Cherokee Lakes in the north. Then, in 1894, major forest fires burned 203 square miles of forest in the western Boundary Waters around La Croix Boulder Bay and Crooked Lake, as well as other smaller areas, including the forest around Alton, Sawbill and Kelly Lakes.

Even the fire-suppression management that went into effect after the 1910 fires, however, could not prevent what happened in 1936. During "the great drought of the 1930s," a decade-long hot, dry period, a state record–tying high temperature of 114 degrees, first established in 1917, was recorded on July 6 in Moorhead, Minnesota. Prolonged record-breaking hot summer weather combined with a seven-year drought resulted in widespread forest fires, including thirty small fires in the eastern Superior National Forest. A lightning-ignited fire that started on July 12 burned thirty-two hundred acres of forest around Cherokee Lake and thirty-five hundred acres around Frost Lake. Then, in June 1948, a forest fire burned twelve hundred acres at Plouff Creek, crossing the Sawbill Trail and stranding guests at Sawbill Lodge for

several days. As Bill Hansen's mother, Mary Alice, recounts in *Sawbill: History and Tales*, a gap in vegetation remained noticeable until the late 1980s. As we were driving down the Sawbill Trail in 1987, I noticed an area with sparse vegetation.

Joining us this year were Dad's golfing friend of many years, Bill; my high school and college friend, Jim; and Jim's nephew, Buck, who is a couple of years older than Eddy. Bill has a ready laugh and a simple, straightforward way of expressing himself. Bald, broad chested and muscular, he's a couple years younger than Dad, so he calls Dad "the old fart." This year turned out to be the first of twenty-two years that Bill would canoe with us. For Jim, it was the first of three consecutive years.

After we had been out for a few days, I suggested we take a day trip to Alice, a lake we had long wanted to see. Jim and the boys wanted to hang out at the campsite, so Dad, Bill and I packed our lunches, fishing poles and rain gear and set off in my newly purchased canoe.

"How about if we take a little detour to see the pictographs on Fishdance?" I asked. Dad and Bill readily agreed.

Paddling with a bright sun in a deep blue sky, we soon arrived at a cliff where we thought the pictographs might be. We paddled over to it, and there they were, faint red marks on the flat rock. We steadied our canoe at the base of the cliff and sat gazing at the paintings.

Next to two red handprints was a red canoe with two passengers. The passengers were depicted as round lumps without arms or heads. Directly below the canoe was the figure of a human shape with a raised left hand. Whether the hand was raised in greeting or was holding a weapon, I couldn't tell. To the right of the figure was what appeared to be a four-legged animal with a swayback, possibly a moose. Beside the other handprint was a smaller human figure. We wondered whether the figures, especially the larger one, represented humans or Wakan-Tanka, the Mysterious One—or maybe something else entirely. What really mystified us were three other objects. One looked liked a crab walking on nine legs, except it also had appendages coming out its top.

"What do you think that one represents?" I asked, pointing.

"Could be a large canoe viewed from above with paddles extending from the sides," Dad said.

That seemed like a possibility. None of us, however, could come up with an explanation for the other two objects. One consisted of five vertical bars crossed by two horizontal bars in the shape of a cradle, or maybe it was some

sort of decorative emblem. Perplexingly, the other one looked for all the world like an elephant with its trunk curled back toward its head.

"Sure makes you wonder," said Bill.

What we do know, according to a number of sources, including Michael Furtman's *Magic on the Rocks: Canoe Country Pictographs*, is that there are about four hundred pictographs painted by Ojibwe artists on granite cliffs and outcroppings across the Canadian Shield, usually located on lakeshores a few feet above the high-water line. Half a dozen of those sites are in the Boundary Waters, and about twenty-five are in Quetico Provincial Park. Some pictographs may have been painted as recently as 1900, but most are probably older. Created from a mixture of red ochre and rendered sturgeon skeleton, and possibly sturgeon oil or bear fat, the images have since bonded with the rock on a molecular level and are extremely durable. They have been variously interpreted as hunting stories, legends or spiritual accounts of coming-of-age dream quests.

The ones we were looking at were faint and partly obscured by lichens. Some images were so faded that they were barely visible. As with the ruins of ancient Greece and Rome, their incompleteness made them more mysterious and suggestive than if they had been vivid and whole.

Bill and Steve shooting the rapids on the way to Alice Lake.

Continuing to Alice, we walked partway down a portage to survey a set of white-water rapids. The map showed a portage around them. The rapids were steep but short, with a clear channel, so Bill and I decided to shoot them while Dad walked the portage. Dad took a photo of us splashing down the chute. Although we took on water, we didn't swamp.

The next set of rapids was more extensive. Emboldened by our first success, we decided to give them a try. We were hitting the *V*s that mark the channel pretty well, but halfway down we realized the current was more than we had bargained for, and we got hung up on a rock. In an instant, the current turned us, and we capsized. We struggled to our feet in the waist-deep, fast-moving water.

"Hey, guys, I lost my glasses," Bill said.

We tried to find them in the rushing water. No luck.

"Were they your sunglasses or your regular glasses?" I asked.

"My regular glasses," he said.

Then we saw the canoe. It was caught on something about twenty feet downstream. As we made our way through the rushing water toward it, we realized it was pinned on its side, its bottom wedged against a boulder, its top exposed to the full force of the current. My heart sank when I saw that its bottom was bent upward and nearly touched the thwart on top. Not only was this my newly acquired canoe, but we also needed it to paddle out of the wilderness. We had to salvage it.

We tugged at it, but it wouldn't budge. Then Bill waded to shore and returned with a six-foot log. We worked one end between the canoe and the boulder, and with all three of us putting our weight against the log, we managed to free the canoe from the current's grip. As we walked it through the current toward shore, we took turns losing our footing on the slick rocks and splashing down on our butts.

After we hauled the canoe up on shore, we examined the damage. The bow and stern were resting on the ground; the midsection rose a good eight inches into the air.

"Well, it's no good to us like it is," Dad said.

"We have nothing to lose," Bill agreed.

With that, we got to work. With Dad acting as lead engineer, we positioned two logs so that they were parallel to one another and then set the canoe on top of them with about a foot extending on either side.

"You're the youngest," Bill said.

I climbed into the canoe and started jumping up and down.

"A little more this way," said Dad.

"A little more that way," said Bill.

From time to time, I hopped out, and we flipped the canoe over and looked down the length of the keel to examine our progress.

"A few more jumps should do it," said Bill.

By the time we finished, the result was remarkable: the keel was as straight as an arrow. I kid you not. There was not even the slightest waver. We hauled it through the brush to the portage trail, which we should have taken in the first place, and then carried it to the entrance of Alice and placed it in the water. To our astonishment—and relief—it didn't leak. Not one drop. We had been foolish to attempt the rapids, especially when we were separated from the rest of our party, but we were proud of our handiwork. For the rest of the trip, we joked about our Wilderness Canoe Repair Shop.

After our escapade, it felt wonderful to be on Alice. At last. We were taken by its expansive beauty, especially its long sand beach extending along the eastern shore past the first campsite on the right. We stopped for lunch on a little rock spit of an island, our shirts and pants draped over a small balsam to dry.

Back at camp, I sat down with my log in the sun. After a while, Bill joined me. I asked him where he grew up, and he told me Britton, a town of fourteen hundred in the northeastern corner of South Dakota, but every year as a child, he traveled with his family to Minneapolis to visit his aunt, who had a cabin on Lake Minnetonka back in the days when cabins there actually resembled cabins rather than mansions. On one trip, he and his family drove around the North Shore of Lake Superior, and he has fond memories of visiting Gooseberry Falls (which he pronounces "Goozeberry Falls"). His father was a pharmacist, but according to Bill, his family was not well off.

"Nobody made any money in those days," he told me. We sat for a while without talking, and then he said, "I've been wanting to go on this trip since the first time I heard about it from Larry."

"I'm glad you did," I said.

He and Dad have been playing golf together for thirty-five years. When I was a teenager, I used to caddy for Dad on his Saturday morning golf outings, and Bill was a regular member of Dad's foursome. With his quick smile and easy laugh, I always liked him the best. And now he has the Boundary Waters bug—he's enthusiastic about every aspect of the trip, has a deep appreciation for nature and natural beauty and is respectful of the wildlife and the environment. You couldn't ask for a better canoeing partner.

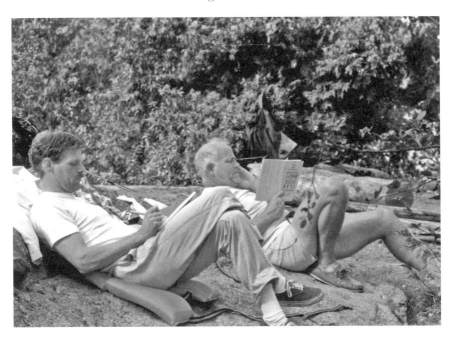

Steve writing in his log while his dad's friend Bill reads.

It rained during the night. The next morning, Dad emerged from his tent in a blue sweatshirt and long underwear bottoms. "Well, our day is intact," he said. "We've had our rain."

"Coffee's almost ready," said Bill.

"Not ready?" said Dad with a smile. "Think I'll bitch."

On our last evening out, Bill, Eddy and I paddled around the lake at dusk looking for beavers. We saw three. Every time they slapped their tails, they made us jump. Bill did more listening than watching, though, since his view of our darkening surroundings was further darkened by his sunglasses.

MY BROTHER LARRY'S RETURN TRIP, THOUGHTS ON PORTAGING, AN EVENING CANOE RIDE AND THINGS THAT GO BUMP IN THE NIGHT

Our newcomers from last year—Jim, Buck and Bill—have joined us again this year, 1988, as has my brother Larry, so we have seven people on our trip, our largest group ever. Eight years have gone by since Larry canoed with us. When he last dipped his paddle into Sawbill Lake, he was thirty-three. Now he's forty-one.

Working against a headwind paddling north, we found a lovely island campsite on Smoke and had our traditional first night's dinner of steak, baked potatoes, salad, runny pudding and wine. Larry teased Dad about the white zinfandel wine in a cardboard box he had brought, calling it "Chateau Ripple." From that day on, Dad has called the wine we bring "Chateau Ripple." After dinner, Larry, Bill and I headed out on the water for an evening of stargazing and watching the Milky Way spread across the night sky. Two spectacular meteorites flashed across the heavens, leaving long bright trails in their wake, and several satellites passed overhead, connecting the heavenly dots.

The next day, the heat was oppressive as we paddled across the lakes and lugged our gear over the portages. Many people consider portaging grunt work, an unwelcome interruption from paddling, an evil to be endured or at best the price to be paid for a beautiful destination, but for me it's part of the rhythm of travel in canoe country. It gives me a break from the group, some time alone, time to think. Whether hot or cold, wet or dry, tired or

Larry, Steve's dad and Steve in 1988.

peppy, I welcome the opportunity to stretch my legs, exercise a different set of muscles, follow a winding trail through the trees, smell different smells from those on the water and see trees and plants close up rather than from a distance. I especially enjoy doubling back for the next load, when my hands are free to swat any pesky mosquitoes, my view unobstructed by the canoe overhead, my shoulders liberated from the weight of my equipment. On my first few steps, I feel like I'm floating above the trail.

When it comes to portaging, most canoeists fall into four camps: those who love it, those who hate it, those who tolerate it and those who consider portaging a test of their strength and endurance, an obstacle to be overcome, an Everest to be mounted. In the latter group falls P.G. Downes, the explorer who canoed some of the same rivers and streams that Ober explored. In *Sleeping Island*, Downes describes how "packing over the portages has a peculiar limiting and brutalizing effect on the mind." His description of the excruciating pain one feels and the thoughts that run through one's mind while portaging is the most amusing I've read anywhere:

> *There is an odd, savage, masochistic joy in finding yourself able to pile on more and more until you can just stagger to your feet. As you trudge on,*

Above: Beginning a portage beside a canoe landing.

Left: Taking a light load.

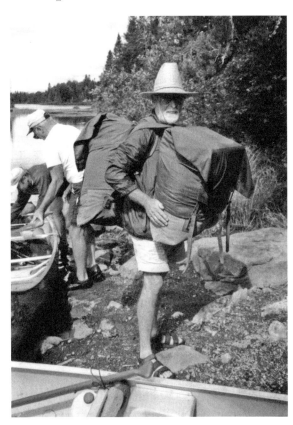

Right: Steve's dad double packing, with Duluth packs both front and back.

Below: Bill portaging.

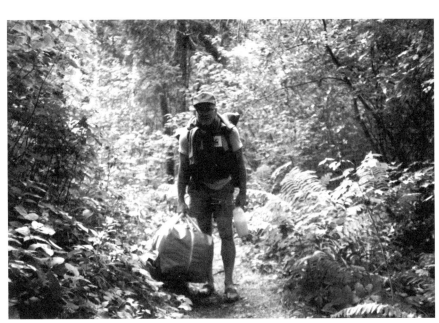

unable to turn your head to right or left, unable to lift your eyes more than a few feet from the ground, the whole world begins to shrink into a focus of pain and short gasps of breath; the deadening pressure of the strap on the top of your head seems to be forcing it down through your shoulder blades. After a few hundred yards, your neck muscles begin to shriek in remonstrance, and it is an aid to grasp the two straps on each side of the head and pull them and the load forward. If the load is properly balanced, not the back but the legs tire first and begin to give way at the knees. As you go along, sweat and blood spattering to the ground, you concentrate in a fanatical, blind struggle with the load and the length of the portage. Instead of a desire to rest, a furious impatience begins to fire you with dull sullen rage. The crushing weight, after a while, sets up a rhythm with the pounding of the blood in your ears, and to break this oppressive thundering you alter your pace to a faster shuffle. The struggle between you and the load becomes a murderous and vengeful obsession and you hear your mind saying: "I'll show you, you bastard. I won't stop and let you down on the ground. I'll lug you over if it's twenty miles."

Then, in language approaching poetry, Downes explains why the words, "By god, there is a man that can pack!" are so sweet to the man of the North: "The North is so crushing, it gives away before the ineptitude of man so slightly, its rewards are so withheld, that these small conceits are magnified out of all proportion and are warming wine to the spirit."

In stark contrast, Florence Page Jaques loves everything about portaging:

After miles of sunny waters, to have a chance to use your legs instead of your arms for propulsion, to plunge into crisp, shadowed path, sundering ferns and bushes, brushing spiced boughs, a turquoise lake behind, unknown water ahead, feet clinking on the stones! In our doubled trips across, I never get quite used to leaving half of all our worldly goods sitting unprotected on the rocks. Nor can I ever take for granted the wood fragrance, so different from the smell of the air on the lakes. I have pine scent inextricably mixed with portages now; one will always make me remember the other.

Solidly in Florence's romantic camp is Justice William O. Douglas, who in "Quetico-Superior," published in *My Wilderness—East to Katahdin* and also in *North Writers: A Strong Woods Collection* (edited by John Henricksson), writes in prose approaching the color purple:

These portages bring discoveries of other kinds. Each was to me an exploration, a launching into the unknown…Each is filled with expectancy, whether it be short or long, steep or flat, winding or straight. Somewhere ahead is a new sapphire lake with a personality of its own. The first sight of it through the trees is always a joy. It stirs the imagination, beckons one onward. It promises the prospect of beavers slapping the water with their tails, loons calling, mergansers skimming the water, graceful points painted red and gold, a lake trout flashing color in the depths, moose feeding on lily pads in a bog. Every lake is a new chapter, with its own theme, its own challenge. Portages bring the expectancy of high adventure ahead. Every streak of blue seen through stands of pine and spruce of the northland has the magnetism the voyageurs felt. It invites one on and on—on to flaming sunsets, moonlight nights, and majestic white pines murmuring in the wind.

Not only do I share Justice Douglas's appreciation of portaging, his zest for canoeing, his admiration of Rachel Carson's *Silent Spring* and his love of the natural world, but I am also personally indebted to this distinguished

Bill, Steve and his friend Jim at the end of a portage.

Minnesotan for his role in swaying the other justices on the Supreme Court to block construction of a dam that would have flooded the Red River Gorge of eastern Kentucky—the same area Dad and I canoed on our harrowing 1971 trip. To see firsthand what he helped preserve, Douglas visited the area in 1967, just four years before we did. Although I didn't know it at the time, the Douglas Trail there is named in his honor.

At the beginning of a portage, I wedge the paddles between the seat and the thwart of my seventeen-foot, sixty-eight-pound Alumacraft to reduce the number of loose items to carry. Then I lift my canoe the way Bill Hansen showed me. Standing near the stern facing toward the bow, I grasp the canoe by the gunwales, hoist it to one knee, kick it up to my shoulders with the bow still on the ground and then walk forward until my shoulders are in the yoke.

Depending on the terrain, I usually carry a canoe about one hundred rods without stopping to rest. Just the same, I keep my eye out for a canoe rest. Installed and maintained by the Forest Service, they're usually found at the tops of hills. They're simple affairs, just two short logs, one extending horizontally from a tree about eight feet from the ground, the other bracing it at an angle. Simple, but handy. They allow you to set the bow of your canoe on the crossbar, lower the stern to the ground and step out from under it without having to set the canoe all the way down and then hoist it up again. Using a canoe rest to take the weight off your shoulders on a long portage is a good technique. It allows you to stretch your muscles while you hike back unencumbered, and as you do, you get an unobstructed view of the forest. Then you can pick up the pile of equipment left by someone in your party while they also double back. We call this method "staging" our portages. We think it's faster than each person going the entire distance with a load and resting in place a few times along the way. The last person back tells the returning person what equipment remains to be picked up.

At the end of a portage, unless the shore is too steep or rocky, I like to walk knee-deep into the water and then lower the canoe directly into the lake. That way, you don't have to pick it up and move it again. I learned the technique from watching a burly young man launch his lightweight canoe. Even with my heavier aluminum canoe, the method works fine if you do it right. The trick is to walk into the water until it's at least up to your knees so that you don't have to lower the canoe too far. Also, rather than grasp the canoe by the gunwales or the top of the sides, you reach one arm up and around the rounded side of the canoe and cradle it as you lower it to the water. The farther you reach up, the better your purchase. With one arm

around the canoe, you have good leverage and weight distribution, and then it's relatively easy to lower it without smacking it down in the water.

After an unusually long or tough portage, however, there's a wonderful alternative: as you lower the bow to the ground, someone in your party walks under the stern behind you and lifts the canoe from your shoulders so that you simply step out from under it. As every canoeist knows, there are times when your muscles are so burned out at the end of a long, grueling portage that you can hardly lift the canoe off your shoulders. As a result, many a canoe has been dropped at the end of a portage. At that moment, "Give you a hand with that?" is one of the nicest sounds a canoeist can hear.

It's good having Larry along on this trip. He's as relaxed as I can remember him ever being. He and Dad seem to be enjoying each other's company. Once when I was a boy, Larry and I were out roaming the neighborhood and environs. I remember he told me I had "sticky feet" because rather than explore new territory, I wanted to go back to this pretty green valley we had discovered the day before. He was right. I do have sticky feet. Sometimes I think of all the places I might have seen if I hadn't returned each year to the Boundary Waters—the great Southwest, Glacier Park, any number of National Parks, the rainforest in Costa Rica, the Great Barrier Reef. But each time I return, I enjoy these lakes and forests and granite rocks more. Each visit adds another layer of experience and memories. For me, having my feet stuck in the Boundary Waters all these years has been the right choice.

Just before our trip this year, Bill did what Dad had done in 1985— he retired from General Electric, where he had worked as a mechanical engineer. So both of them began retirement with a Boundary Waters canoe trip. Maybe I should do the same.

The next morning, we watched a mother seagull use the rock off shore from our campsite as a rendezvous point with her two little ones. They would arrive, circling and squawking and clumsily landing nearly on top of her, hunching their heads forward in an attempt to look as pathetic as possible. "Feed me, feed me!" they cried, but she would just turn her back and swim away. Although they still had their juvenile feathers, they were nearly as big as she was. Soon after, we could hear the father calling and circling overhead. Later, Bill and I saw a family of loons, two adults and two babies. We heard the mother hoot to the babies after a dive, and we watched them scoot across the water to her. The sound she made was soft and rich. A single, reassuring note.

"Nature is good," Bill said.

That night, when I asked who wanted to go on an early evening canoe ride, Dad surprised me by saying yes. He usually prefers to stay at the campsite. I knew Bill wanted to go, but he said he would pass. I think he didn't want to prevent Dad and me from having some time together.

Out on the water, Dad asked me what I thought of the job the lumber companies were doing with all their replanting. I told him I thought they were doing a better job than they had in years past, but they weren't leaving enough old-growth forest, defined as trees older than 120 years. The last time I heard, the percentage of old growth in Minnesota had declined from just under 2.0 percent to 1.2 percent, a percentage that in my opinion was moving in the wrong direction. When I asked Dad what he thought, he said, "I think they're doing a pretty good job." I thought about asking him how he was doing since the divorce, which had become final this summer, but I wasn't sure he wanted to talk about it, so I didn't.

Turning our canoe south, Dad and I paddled toward the Milky Way, tracing its journey to the horizon. With each stroke, the canoe lurched, then glided, delicate and responsive to our touch. We were floating among the stars. As the heavens moved silently past, I thought about my childhood.

Larry, Steve and Jim on north Sawbill Lake in 1988.

When I was little, I wasn't always certain of Dad's love. Now, as an adult, I've learned to depend less on his words and more on his actions to know that he cares—actions like moving my wet shoes to where they will catch the morning sun, coming on these canoe trips year after year or just being here with me now in this canoe.

We spent our last night on the north end of Sawbill, on the site on the west shore, surrounded by tall red pines. There's a photo of Jim and me unloading wood from the canoe with Larry standing in the background. One of my favorite photos, it has stood framed on my basement bookshelf for years.

After dinner, I went out by myself for one last midnight paddle. As I paddled up the narrow channel leading to the lagoon north of our campsite, the brush and overhanging limbs gradually closed in on me. It was so dark that I couldn't see the water below me. Each time the canoe bumped an unseen object, I jumped. I'm not the sort to get spooked at night, but with each bump I grew more apprehensive. When I switched on my flashlight, the beam seemed harsh and abrupt, and it interfered with the mystery of the evening, so I switched it off and paddled on in the darkness, feeling ill at ease and tense. I wasn't sure I wanted to know what lay ahead. Then I remembered Bill's words, and I felt myself relax.

Nature is good.

CONCENTRIC RINGS, CHILI CANS AND THE TICKET

In 1989, just before we left the North Shore at Tofte and turned onto the steep hill of the Sawbill Trail, we laughed when we saw the handwritten sign posted on the Standard Oil station. It read, "We will be closed starting Oct. 6 or until the moose has been bagged, cut up & put in the freezer. Thank you. Tofte Standard."

In the car with me were Eddy and my old friend Jim. Again this year, Dad and Bill traveled by plane. Without my brother Larry and Jim's nephew Buck, we were a smaller group this year, five rather than seven.

This was the year the *Exxon Valdez* ran aground, spilling 10.8 million gallons of North Slope crude on Bligh Reef in Alaska's Prince William Sound. It was also the year a radio tower that would have been visible in the Boundary Waters was blocked by temporary injunction granted by Ramsey County district court judge Donald Gross. Proposed by Connecticut developer Timothy Martz, the 611-foot tower was to be constructed on a ridge near Esther Lake in Cook County. The judge accepted the argument of environmentalist Harry Drabik, who sued on behalf of the state, arguing that the tower would ruin the scenic quality of an unspoiled wilderness. I suppose that for people who have never experienced a natural setting free of development or encroachment, a single radio tower might seem insignificant. They might wonder why a lighted tower on the horizon would be a big deal.

It's hard to understand wilderness if you've never experienced it, just as it's hard to appreciate the mystery and splendor of the starlit heavens if you've never seen the night sky unclouded by light pollution. But once you know what wilderness is, it becomes a part of you; it enters your dreams and stays with you always, long after you're too old or infirm to visit in the flesh. For those who know and appreciate wilderness, a flashing light on the horizon fundamentally alters the setting and destroys the illusion of timeless travel. A tower located within sight of wilderness has special power. Its pulsing light travels in two directions: it flashes in and takes wilderness out.

The blinking lights of a high-flying plane and the fast-moving dots of satellites have a similar effect, but their intrusions are unavoidable and fleeting. Even the drone of a motorboat is a temporary intrusion into a largely non-mechanized, undeveloped, natural setting. But a tower with a permanent light flashing twenty-four hours a day is materially different. So fragile is wilderness that such a structure effectively removes a swath of land and water from its designated status as a protected area, thereby depriving us of the opportunity to experience a vanishing landscape, a relatively small but glorious example of what the North American continent was like before we altered it, in many cases beyond recognition, from its natural state.

We put in on Kawishiwi Lake in the rain, camped on Square and then headed on to Polly, where we arrived early enough to enjoy a sunny, pleasant afternoon on our campsite. As Bill was preparing our evening fire, I rooted around the food pack until I found our chili dinner, which we had brought in two large cans. It was against the rules to bring cans into the Boundary Waters, but I planned to pack them out in our garbage bag. As I began cooking, with the two yellow cans resting on the fire grate in plain view, two DNR officers suddenly appeared at our campsite. They had landed their canoe out of sight down shore and had sneaked up on us. One of them was toting a .45 automatic pistol in a hip holster.

"Hey, don't you know you're not supposed to have cans in the Boundary Waters?" the one with the pistol demanded.

Jim, always the diplomat, tried to convince them that we had no intention of leaving the cans. "You'll never meet anyone who cares more about the environment than our group leader," he said in my defense. He invited them to look in our garbage bag to see all the litter we had been picking up along the way. He even asked them if they were hungry and invited them to have dinner with us. In response to the one officer's questions, I mentioned Sawbill Canoe Outfitters, and he didn't know who they were. How could

you patrol this area of the Boundary Waters, I wondered, and not know the name of the only outfitter at the end of the Sawbill Trail? As we found out later, they had been assigned to the Boundary Waters from outside the area as part of a training program.

When the armed officer asked to see my permit, I took it from my rain suit pocket, where it was still damp from the previous day's rain, and gave it to him. He pulled out a tablet, wrote out a fifty-four-dollar ticket and handed both the ticket and my permit to me.

"Next time, keep your permit dry, Jack," he said.

After they left, we looked at one another in stunned silence. We felt as though we had been assaulted.

"We'll add the ticket to the group's expenses," Dad said "We'll all help pay for it."

Dad is slow to anger, but he was seething. I was both angry and embarrassed. I believe in the rules. Outlawing cans in the Boundary Waters has been an effective way of reducing litter and protecting the environment. There was a time when, off in the brush near every campsite, you would find a pile of accumulated trash, dumped there rather than hauled out by campers because that was the way it was done. But the old days of dumping trash or burning out your cans, filling them with sand and sinking them in the middle of the lake were long past. I had broken the law and deserved the ticket or at least a warning. It's not that I objected to the two officers doing their jobs. What bothered me and shocked all of us was the rude, aggressive manner in which we had been accosted. The one officer in particular seemed to be looking for a fight. After the trip, I filed a complaint with the DNR, accompanied by a letter detailing the encounter.

Subdued, we ate dinner with only occasional conversation. After cleanup, Jim, Bill and I went hunting for beaver on the north end of the lake. We paddled to the right of the island by the other campsite, where we heard a splash that made us jump. We followed the sound. Two curving lines across the water made a wide circle around us. Then there were two more splashes, followed by two more jumps. It felt good to laugh.

From Polly, we day-tripped to Koma and Malberg under a gorgeous blue sky and then traveled up the Lady Chain to Beth, where we camped near the rock cliff next to the portage on the east shore. After dinner, Eddy, Jim, Buck and I climbed the bluff, which afforded a stunning view of the lake. With three islands lined up in a row, framed by high hills on each side, with Dad and Bill's silhouetted canoe cutting a slow line across the water and with

the colors of the setting sun tinting the pastel blues and greens of the water, it was an unforgettable picture.

"Hey, Eddy," said Jim. "Do you know what concentric rings are?" To demonstrate, Jim tossed a small stone into the water below us. As I watched dozens of perfectly shaped circles radiate across the still water, I wondered how something so simple could be so lovely.

Dad and Bill's canoe was heading toward camp. Tracking their slow but steady progress, I was reminded of how canoes blend into the environment. Canoes belong and have belonged here for thousands of years, first as simple dugouts and more recently as lighter-weight birch-bark canoes. Today, other than the bang of an aluminum canoe being dropped on rocks after a long portage, an occasional metallic scuff on a submerged rock or the imprint of a keel in soft mud, the canoe makes no sound and leaves no mark. With Old Towns and other newer models that are being redesigned to make them lighter, the graceful upward curve of the bow and the stern of the old Alumacraft canoe—a line that mimics the line of the birch-bark canoe—is lost. But even a flat-looking canoe is beautiful. As it moves silently through the water, it becomes a part of the beauty around it.

Later, when I went for a paddle with Bill, I asked him if we were staying out too long.

"Oh, no," he said. "You're steering. You go wherever you want to go."

So we paddled the entire length of the lake, did a lap around the cove at the west end and then headed back toward the campsite into the wind—a crazy thing to do, paddling just for fun when we had spent half the day paddling. But paddling in the late evening or at night, when the unloaded canoe moves almost effortlessly through the water and you can feel your motion more than see it, is a joy. Bill's a powerful paddler. He and I could paddle for hours on end.

"If I die on one of these trips," he said, "I'll be a happy man. Don't even carry my body out. Just leave me here."

"Bill," I said, "there are laws against that sort of thing."

"I don't care. Just leave me here."

He means it, too. Like Benny Ambrose, he would rather die where he's happy, in a natural setting, than have his life prolonged artificially while immobilized in a hospital bed.

After dinner, I helped Dad with cleanup. He likes to wash, so I dipped the plates, cups and utensils into the big pot of boiling hot water while Eddy

held a flashlight for us. I asked Dad when he and his fiancée, Joan, were coming to visit us in Minneapolis.

"Maybe next spring," he said.

I hope they come. We need to take this next step in our father-son relationship, one that no longer involves my mother.

On Hazel, we met two rangers with the Forest Service. They introduced themselves, coincidentally, as Larry and Steve. They told us they had been checking on the progress of the work crews who were installing the new fiberglass biffies, but they had been called out on an emergency to fight a fire. They were relaxed, easy-going guys, and we enjoyed talking with them. We told them about our unfortunate encounter with the two DNR officers and described their rude and threatening behavior. The rangers said they were sorry we had been treated so badly, and they explained that their approach was to educate rather than threaten campers, although sometimes issuing a ticket was the best way to make a point.

"By the way," one of them said politely, "mind showing us your permit?"

THE SAWBILL TRAIL AND DECLINING MOOSE

W hen I saw Bill Hansen at the beginning of our 1990 trip, he told us that the Forest Service had requested a half-day meeting with Joe Alexander, DNR commissioner, to discuss a problem they had the year before with two DNR officers and that my letter had played a part in the discussion. Apparently, we weren't the only ones who had been upset by the officers' aggressive manner. At the end of our trip last year, a woman told me that the two officers had appeared on their campsite and wanted to inspect their packs. When they declined to give the officers permission, the one with the pistol patted down the packs. It felt more like a drug bust, she told me, than a search for cans.

Our string of pleasant trips continued. One memory stands out in particular from our 1991 trip: the day trip we took from Malberg down the Kawishiwi River to Amber. I remember paddling with Bill on a gorgeous sunny afternoon. On our way back to Malberg, we saw a couple making camp, the only people we had seen all day. Then, as Bill and I passed the island, the one with two campsites, we reached that point in a trip when paddlers stop without a word. Maybe it's a sign that the rhythm of paddling, the rhythm of the day and the rhythm of the trip have all converged, and the two paddlers are now completely in sync. It seems to happen on cue. For a long time we sat drifting with the breeze, taking in—and taken by—the beauty of our surroundings.

"How would you describe this to someone who has never seen it?" I asked. It was a question we often ask ourselves on these trips.

"You couldn't," Bill said. "You have to be here and see it for yourself."

As we continued our drift, we talked about forest succession and the redwoods in New Zealand and how they have been alive since the time of Christ. Then Bill told me he would like to have his son come with us one year.

"You would like him, Steve."

I think I would. If he's anything like his father, I know I would.

"What's his name?" I asked.

"Paul. He lives in Texas. He's about your age, a few years younger."

At the beginning of our 1992 trip, Bill Hansen told us about the compromise involving the rebuilding of the Sawbill Trail. His mother, Mary Alice, writes about its history in *Sawbill: History and Tales*. Constructed for the purpose of reaching logging operations, the Sawbill Trail was originally laid out along the path of least resistance, sometimes through low-lying areas that were subject to flooding and washouts, conditions that plagued travelers until the upgrade. The trail had its origins in the Springdale Road, which was constructed about 1898 from Tofte, where settlers had arrived in 1893, to a settlement named Springdale, a couple miles inland from Lake Superior. The first mile of the Springdale Road would become the first segment of the Sawbill Trail. About 1924, the citizens of Tofte passed a bond issue for $20,000 to build the Temperance River Road, which later became the Sawbill Trail. For the first mile, it followed the earlier road from Tofte to Springdale before turning north from Carlton Peak toward Sawbill Lake. When the town's money ran out, Cook County continued construction. By June 1925, approximately five miles had been completed (to a point near where the present 600 Road joins the Sawbill Trail). By 1928, the road had been constructed as far as the railroad grade. By May 1931, the twenty-four-mile road from Tofte to Sawbill Lake had been completed.

The plan Bill told me about was to upgrade the trail by widening its clearance for a fifty-five-mile-an-hour, two-lane paved highway. In 1990, when the bulldozers started clearing the first segment from Tofte, there was an uproar. People protested that the rebuilding would alter the trail's primitive character. On October 15, 1991, a compromise was developed by the Sawbill Trail Consensus Committee, facilitated by Forest Service Tofte district ranger Larry Dawson. The compromise resulted in special variances being sought from state and federal highway administrations so that only the

first three miles from Tofte was paved. After that, it was decided to apply calcium chloride for dust abatement. Road clearance was widened from forty-five to fifty-six feet (rather than the sixty-four feet originally proposed) for a forty-five-mile-an-hour, nine-ton road with twelve-foot driving lanes, two-foot shoulders and three-foot ditches and trees cleared an additional ten feet on the ditch slopes on both sides of the road. The road was rerouted near Plouff Creek, known as Dead Man's Curve because of its many accidents, reducing the overall length of the trail from twenty-four to twenty-three miles. Clearance for the last six miles was not altered. Today, the Sawbill Trail has an increasingly rustic feel as it approaches Sawbill Lake.

In 1993, we were joined by my twelve-year-old daughter, Kate. In the preceding years, she had chosen to stay at home with her mother and grandmother, but this year we had talked her into coming. She was not only a strong paddler but also a bold and capable camper who taught us a few things about organizing our gear.

It was on our 1994 trip that I met Bill's son Paul. Dad, Bill and Paul arrived by plane. While Dad waited at the outfitters for the three of us—Eddy, Eddy's friend Jonathan and me—to arrive by car, Bill and Paul checked out campsites on the north part of Sawbill. With Eddy and Jonathan in one canoe and Dad and I in another, we met Bill and Paul as they were coming south on the lake. As we drifted up to their canoe, I leaned over and shook Paul's hand. I noticed he had a more compact build than his dad, and like him, he looked strong. Then I greeted Bill, who told me he was recovering from an operation to repair torn tendons in his right shoulder.

"My arm's at about 50 percent," he said.

"To hell with your arm," I said. "Where's the coffee?"

I was pleased that Paul was quick to laugh like his father.

Heading to the west bay of Sawbill, the one that leads to Kelso, we found both sites open. We settled in on the farther one for a pleasant evening, savoring our steaks, potatoes, salad, wine and runny pudding. Already the concerns and worries of our daily lives seemed distant.

The next day, we traveled north from Sawbill to Cherokee. That night, as we were standing by the fire, Paul told a story about how a buddy had avoided service in Vietnam because he had an inner-ear infection, which delayed his going for two weeks, and during that time the policy was changed to make service voluntary. As he told his story, he and Bill stood side by side, hands thrust in their back pockets, swaying back and forth. From the similarity of their movement, it was impossible not to recognize them as father and son.

On a day trip to Cash, Paul and I carried both our canoe and our fathers'. We're the middle generation, the strongest now. On Cash we saw an island with dozens of large stick nests atop dead trees. The nests, maybe cormorant or heron, appeared to be abandoned. Paul was excited to see a true wilderness lake. In fact, he was excited about everything. With his four young children and wife and a demanding job as a district manager for Wells Fargo Bank in San Antonio, it had been hard for him to get away. Having finally made it, he was thrilled to be here.

On the long paddle back across Cash, Eddy and Jonathan were on one side of Paul and me, and Dad and Bill were on the other. As we moved along in formation, Dad talked about how he had survived being cut from flight training school by doing forty perfect touch-and-goes. I love hearing that story.

After flight training school, Dad was initially stationed in India and then in Burma, at Myithyina on the Irrawaddy River. His principal mission, an extremely dangerous one, was to fly supplies over "the Hump" of the eastern Himalayan Mountains. He and his crewmates served as replacements for a squadron that had lost four planes just a few weeks earlier. Taking off in the dark and without radar, that squadron had been told in a briefing to fly at 11,500 feet to clear the mountains. The mountains, however, topped out at 11,500 feet. Four planes went down, and sixteen crew members died. The wreckage from the planes was later found near the tops of the mountains. They had almost cleared the peaks.

One of Dad's missions was to help move Chiang Kai-shek's army from Burma to Kunming, China. When Paul asked what kinds of things he transported, he said, "Jeeps, soldiers, mules, horses and anything else in his army." They often took off at night, without the benefit of ground navigational aids. If they had used any aids, Dad explained, the Japanese could have detected them. "So we flew by compass, hoping we wouldn't wander off course," he said, "and then at first light we tried to figure out where we were by using visual references below." Even then, they had to be careful. "You didn't want to fly into a cloud with a rock center," he said.

"What's a cloud with a rock center?" Eddy asked.

"A cloud that obscures the top of a mountain," he said.

The next day, we traveled to South Temperance, where two guys were just leaving the campsite we wanted as we arrived. Later, on an evening paddle with Paul, the wind died and the water turned smooth as glass, with a full moon rising. Paul and I talked about our fathers, marveling at how they were still able to pack their gear and were fine with sleeping on the ground. How

Steve's dad hoisting a canoe.

many more years will we be canoeing with them? we asked. As we watched the delicate lines of a beaver cutting across the water, I braced myself for the slap. Then, with that beaver still visible, another one just behind our canoe slapped. I jumped, and Paul laughed. I hadn't noticed the second one.

The next day, Bill got up early and made the oatmeal his way, dumping all the envelopes of different flavors into one pot. I remembered how Kate hadn't liked the mix. As with my dad, sometimes you have to let Bill do things his way. Later that day, we noticed a red haze shading the sun and masking the brilliant blue of the sky. We wondered whether it was smoke from Canadian forest fires. That night, the full moon rose rusty red. I left Eddy and Jonathan stargazing on the rock and went for a paddle. As the moon rose higher in the sky, it turned white. Again, the water was perfectly still, and every little sound seemed amplified. I felt as though I could go anywhere, like a bird in flight, not just right or left but also up or down. In *Boundary Waters Canoe Area Wilderness*, Kate Crowley and Mike Link describe a similarly magical night:

> *This night was so calm that our blackened bow wake rolled into the darkness like giant waves, and we could hear them lap on the distant shore…We*

were not a canoe any longer, we were a spaceship, gliding quietly from constellation to constellation.

I was just about to head back when I heard something crashing through the water. The sound was louder than my wake striking rock. It was more like a large animal thrashing across the surface. After a couple dozen strokes in the direction of the disturbance, I came upon a loon that lifted its wings and reared back in the water, its neck arched, its big white chest glowing in the dark. Then it dropped low in the water and circled my canoe. Eddy and Jonathan heard the commotion from shore. When I returned to camp, they asked me what the ruckus was. Loons. Crazy animals. There's a reason for the expression.[‡]

Earlier in our trip, in the narrows of Cherokee, we had seen a swayback moose. It was standing in the shallow water, heaving. Moose, with their thick coats of hollow hair, are so well insulated that they struggle in temperatures above fifty-five degrees. At sixty-five, they begin to pant, expending energy to cool themselves. This one was clearly stressed, either from the heat or old age, or maybe both. With temperatures rising as a result of all the carbon we're releasing into our atmosphere, I worry about the future of moose in the Boundary Waters, the southern limit of their range.

The moose population in northeastern Minnesota has been declining, apparently as a result of an infestation of tiny, nearly invisible "winter" ticks. As reported in the March 16, 1989 *Minneapolis Star Tribune*, "A recent Department of Natural Resources survey showed that the state has lost nearly half of the 6,700 moose counted in Minnesota in 1989." According to that story, in the forty-eight contiguous states, Minnesota is second only to Maine in its number of moose. Apparently, the ticks were attaching themselves to the moose in such large numbers that the frenzied animals sought relief from the irritation by rubbing themselves against trees. "In the process," the paper reported, "wide sections of hair, the moose's protective winter insulator, are rubbed off, and the moose probably die from exposure."[§]

[‡]. There are an estimated twelve thousand adult common loons in Minnesota. Their numbers appear to have held steady in their first migration north since the catastrophe of April 20–July 15, 2010, when BP's *Deepwater Horizon* oil spill released 206 million gallons of oil into the Gulf of Mexico, where many of Minnesota's loons spend the winter.

[§]. In 2011, an aerial survey conducted by the Department of Natural Resources found that the number of moose in northern Minnesota, which is at the southern range of this heat-sensitive animal's habitat, fell from eight thousand in 2005 to fewer than five thousand. Their numbers also are declining on Isle Royale and in southern Manitoba and Ontario. They have vanished from northwestern Minnesota.

With our warming climate, will our moose migrate farther north after thousands of years of inhabiting the area? In the decades ahead, will Minnesota lose its moose population completely? In *Paddle North*, Greg Breining suggests that, given our disturbance of the natural balance of things, we may want to rethink our approach to wilderness management. "What is the sense," he asks, "of pretending there is untrammeled nature in the face of human-caused climate change?" Maybe the time will come, he suggests, when we should try to "rescue" the species that are suffering, from conifers and birch trees to lynx and lake trout. And even if we do intervene, what if we lose the battle and this remnant of an ecosystem dating back ten thousand years slips away? I like Breining's answer:

> *Such a loss would be a tragedy to those of us who know canoe country as it is. But it would be wrong to take this sentiment, and the anger and despair it provokes, too far. For icons are the things we seize upon to fix a place in our minds, but they are changeable and illusory. In some distant future, there will still be a tumult of life, a robust mix of species in the north. The people of that time will celebrate new icons—no longer moose, lynx, and spruce, but white-tailed deer, bobcat and red maple.*

My grandchildren (if I ever have any) may not have the same Boundary Waters I know, but if we hold firm in our commitment to protecting this precious resource, they *will* have a Boundary Waters they can experience, explore and love. In the face of unavoidable change, I'm comforted by that thought.

13
THE SAG CORRIDOR WILDFIRE, BOUNDARY WATERS BOOMERS AND THE END OF THE KNOWN WORLD

S pectacular" was Dad's word for our 1995 trip. I agree. Also relaxing, low-key and adventuresome.

We had good weather, a thunderstorm on Friday night on Alice and a few cloudy mornings but otherwise sunny. The days were warm at first and then cooler toward the end. We had tail winds both going in and going out. Moonless, mostly clear nights. Even Dad stayed up till dark on Alice and Koma.

I didn't write in my log this year. In place of written entries, I have a different sort of record. Dad brought his video camera this year. Now when I listen to his voice narrating the trip, I see the Boundary Waters through his eyes. I love the way he says, "That's some kind of pretty." Unfortunately, his batteries died before the end of our trip, so the record is incomplete.

Debbie and I bought a cabin this year on the Middle Eau Claire Lake, twenty miles north of Hayward, Wisconsin, where coincidentally Dad, Larry and I had began our 1981 Namekagon River trip. Dad and Bill flew to Hayward. It was good to see them so relaxed as they sat on the deck overlooking our bay, sipping their gin and tonics and later taking a ride across the lake for hamburgers, with Dad and Bill standing shoulder to shoulder at the front of the old Fiber Foam boat that came with the cabin.

As we put in on Kawishiwi Lake, we saw huge billowing clouds against the blue sky to the north. At first we thought it was a thunderhead. Then we realized we weren't seeing clouds; we were seeing smoke. It appeared to

be coming from the direction of the Gunflint Trail. Later, I learned that a major forest fire, the Sag Corridor wildfire, had started on Romance Lake and burned around the Saganaga Lake area. Before it was contained, it spread across nine miles, or 12,600 acres, both in the United States and Canada, and it threatened forty structures on the Gunflint Trail. About 8 percent of Quetico was affected, an area larger than the combined area burned in the previous sixty years. Every day of our trip we saw three or four planes, probably water-scooping de Havilland Beavers, carrying water to douse the flames.

For years, it had been our goal to camp on Alice. We had day tripped in 1987, the year we swamped shooting the rapids, but this year we actually camped there. What a gorgeous lake! We loved the panoramic view, the rock points, our sand-bottom "swimming pool" in the bay by our campsite and the relatively warm water.

Back on our campsite, we settled in for happy hour. Dad and Bill really liked the drink invented by one of the guys in my men's group last year—Crystal Light with a wedge of fresh lime mixed either with gin or vodka. The men's group liked it so much that they gave it a name, Boundary Waters Boosters, but Dad keeps calling them "Boomers." I think I like his name better. Whatever name it goes by, Dad and Bill were sufficiently intrigued by its taste to try a couple of extra ones just to make sure they were all right.

On a day trip down the Kawishiwi River, we paddled off the western edge of our map. Like Ober and Billy on their historic 1912 trip to Hudson Bay and back, we had traveled beyond the known world, at least that part of

Steve's dad beside his tent.

the navigable world shown on our map. After paddling a beautiful river, we took a short seventeen-rod portage and then paddled into the bay of a larger lake, whose eastern shore appeared on the left side of Bill Hansen's map but without a name. As we relaxed on an exceptional campsite overlooking the lake from high up on the shore, we wondered which lake we were on. Later, we met two paddlers coming from the opposite direction. When we asked them where they had put in, they told us Ely, but we didn't think to ask them the name of the lake we were on. We didn't find out until we talked to Bill at the end of our trip.

Maybe it was better we didn't know. Maybe not knowing caused us to look at the blue expanse, granite outcroppings and pine-forested shorelines with more inquisitive eyes. I was reminded of the time I was invited by Mike Link to offer a writing workshop to a group of environmental teachers at the Audubon Center for the North Woods in Sandstone. While there, I learned that the staff would delay telling children the names of birds they encountered on field trips. The staff had learned that as soon as they identified a bird by name, the children became less curious. So when the children asked about a bird, rather than tell them the name, they would have

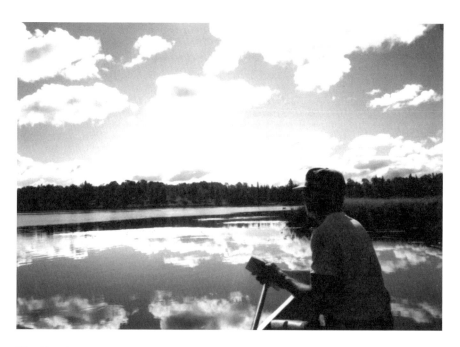

Checking the map.

them describe what they were seeing. Only later did they identify the bird as a white-breasted nuthatch or a downy woodpecker.

Still, not knowing the name of the lake we were on felt oddly disconcerting. Not that the name would have told us anything about the lake. Given the white man's method of naming lakes after aunts, supervisors and whomever, it was unlikely that this lake's name would convey anything about its character, spirit or past significance to the local population.

I also was troubled when the young couple we encountered told us they had begun their trip from another side of the Boundary Waters. We were pleased to have ventured so far, the farthest we had ever traveled west from Kawishiwi Lake, but now the wilderness seemed limited. We weren't going deeper into it, as we had thought; we were heading out. Because of the configuration of the million-acre Boundary Waters, with the Echo Trail cutting into the wilderness from the south and the Gunflint Trail dissecting it from the north, you can go no farther than a two days' paddle into its interior. In *Boundary Waters Canoe Area Wilderness*, Kate Crowley and Mike Link comment on the implications of this configuration: "When you paddle further than two days, you are seldom rewarded with the extra solitude that you feel you have earned. Instead, you begin to meet travelers from other routes seeking the same privacy that you crave."

Now that I knew this limitation, the mystery and allure of this place that had stirred my imagination and occupied my dreams for so many years was slightly diminished. One of these days, I'll have to get a permit from the Canadian authorities as well as one from the U.S. Forest Service, put in at the end of the Sawbill Trail and head north into the less-traveled Quetico wilderness. After that, maybe I'll just keep paddling until I reach Hudson Bay.

We spent our last night on Kawishiwi Lake. As I sat by the campfire with Dad and Bill, I complimented them both for being good campers. They truly are. They're eager, experienced and resourceful. Then Bill talked about the last trip he had taken with his mother. She was ninety-five then. She had died the previous December at age ninety-nine.

"She was ready to go," Bill said. "The last years were hard."

With the fire crackling softly and the wind stirring the pines above us, we talked a while longer, mostly about the trip. Then Dad said that when our children were older, Debbie and I would have to come with him and Joan on one of their annual trips to Grand Cayman. I told Dad I thought he seemed happy with his life.

"Yes," he said. "Except I don't like getting older."

14
A FISHLESS TRIP AND A PACK-RIPPING BEAR

In 1996, Dad, Bill and I were joined by Larry, a friend from Denver and an avid fisherman who had been enticed by my Boundary Waters stories. As luck would have it, however, this trip was the only one when we didn't catch any fish. Not one.

The four of us put in on Brule with a strong wind from the east. With big rollers hitting us broadside, we abandoned our attempt to cross north toward Winchell and turned west, surfing with the waves toward South Temperance. As we approached the portage, something looked odd to me. Then I realized what it was. In place of lush forest, charred stumps dotted the hillside. The pines between Brule and South Temperance—the tall, sheltering trees that had made our 1985 Retirement Campsite feel so cozy— were gone. Earlier that year, in June, a forest fire had burned 4,450 acres around South Temperance Lake. The fire was fought by more than 260 personnel at a cost of $1.5 million.

On South Temperance, we were dismayed to discover that all the campsites were taken, as they were on North Temperance. Now we were in a fix. With the sun low in the sky, we decided against traveling on to Cherokee and looking for a campsite in the dark, so we did what you're not supposed to do. We "dry camped," as Dad calls it, on an "undesignated" campsite on an island. In 1966, the U.S. Forest Service implemented a rule limiting visitors to designated campsites on heavy-use routes. In 1975, the rule was extended

to the entire Boundary Waters area. We weren't the first people to break this rule. There were signs that the site had been used by others, no doubt campers like us who had been shut out. To minimize our impact, we didn't build a fire, we ate a no-cook lunch rather than a regular dinner and we left early in the morning, again without making a fire. It was a rough start for our trip.

The next day, we made it to Cherokee by 9:20 a.m. We camped near the portage on the east shore on the south end of the lake. We had the steak and potatoes we had brought for our first night's dinner for lunch. It was windy, gloomy weather.

While sitting with Larry on the rock point of our campsite, I heard a ripping sound behind me. Knowing what it was, I turned and saw the brown shoulders of a huge furry bear standing on its hind legs, its back to us, its forelegs wrapped around our Duluth food pack. We had left the pack hanging from a rope about six feet off the ground—high enough to keep it out of reach of rodents but not out of reach of a hungry bear. Just as its teeth ripped into the green canvas, I yelled and ran toward it. It turned its big head toward me and stood motionless for what seemed like a long time. Then it dropped to all fours and, in no particular hurry, lumbered away. I made an effort to present myself as a fierce and threatening foe, but as always, I was prepared to execute Plan B. What a magnificent animal.

The next day, we moved on to Long Island Lake, where we stayed on a gorgeous site, the same one we had stayed on in 1979 with Dad, Larry and Tim. From Long Island, we traveled to Muskeg, Kiskadinna, Omega/Ogema (or Whatever-the-Name-of-That-Lake-Is) and Winchell. I love Bill Hansen's enthusiastic description of the route we were taking:

> Head south from Ogema to magnificent Winchell Lake. Pick one of the rock point campsites along the north shore of Winchell. This is a particularly good lake for watching sunsets. If it is calm (and it often is in the evening), it is sheer heaven to drift in your canoe and gaze down the mirror-like lake at a fiery sunset.

Bill once told me that his children tease him about getting carried away with his descriptions, but I'm with Bill. When it comes to the Boundary Waters, I'm a sucker for exuberance.

On Winchell, a good portion of the south shore highlands was blackened, the jagged surface punctuated by charred tree stumps and exposed rocks. Known as the Misquah Hills (which take their name from the Ojibwe word

misquah, meaning "red"), the burned-over terrain dramatized the delicate balance between life and death for the plants clinging to the thin soil. The boreal forest of the Boundary Waters, composed of cedar, spruce, aspen and birch, with occasional stands of white and red pine, always looks rugged, sometimes even bedraggled, especially when a stand of trees has been worked over by spruce budworm, but after a fire, when the vegetation has been burned off and the red granite rock beneath the thin soil has been exposed, it looks vulnerable, both rugged and fragile. Such a delicate balance. On a warm, sunny summer afternoon, with a caressing breeze and the sound of waves lapping against the stone shore, the Boundary Waters seems tranquil and peaceful, but this gentleness is deceptive. It obscures the reality of the region, where life clings tenaciously to the few precious elements that sustain it.

That night, watching the stars and distant lightning, I wondered if my friend Larry was having a good time. He was fit and about twenty years younger than I was, but his back was bothering him. Although he wasn't complaining, now and then I heard him moan.

As I was walking the portage from Mulligan to Lily, I encountered a magnificent sight: a lovely stand of old-growth pines. They were easily two hundred years old. For them to have lived so long—surviving droughts, fires, windstorms and insect infestations, not to mention lumberjacks—was an astonishing quirk of fate. I hadn't seen trees so large since the early 1980s, when Debbie, the children and I had gazed in wonder at the towering red pines in Preacher's Grove at Lake Itasca, the headwaters of the Mississippi River. What is it about a stand of old-growth trees that inspires reverence and a hushed silence? Is it their spirit or their majestic beauty? Maybe it's just knowing how much longer they have to live than we will.

THE BEGINNING OF A SEVEN-YEAR RUN, TOO MANY FISH TO COUNT, NO CAMPFIRES AND THE OLD SAWBILL-ALTON TRAIL

For the next seven years, from 1997 to 2003, Dad, Bill, Paul and I were a regular foursome. Except for the last one, it was a wonderful run of trips. The advantage of canoeing with the same people year after year is that you learn how to travel with your companions. Dad, Bill, Paul and I have canoed so many times together that we know one another's likes, dislikes and peculiarities. After years of loading canoes, hauling equipment over portages, making and breaking camp, cutting firewood, cooking, eating and cleaning up, we have developed habits and routines that made us an efficient unit.

Dad likes to organize things around the campsite, make sure everything is in its place, scout out a likely branch about twenty-five feet above the ground to hang the food pack, tie a rock to the end of a rope, see how many tries it takes him to loop it over the branch (having perfected his method of slinging rather than throwing the rock, thereby achieving greater distance and height while sacrificing some degree of accuracy) and do the dishes. Our routine is for Bill, Paul or me, having taken our last bite of dinner, to say, "Hey, where did my plate go?" and then for Bill to say to Dad, "Larry, why don't you sit and relax for a minute? We'll help you with the dishes later," and then for Dad to say, "I'm just doing the pre-rinse before soaking them."

Bill and Paul are workhorses. They're enthusiastic, eager campers, more even-tempered than Dad or I. They like doing everything that relates to camping, and they're not fussy about how it gets done. Bill has fashioned

some high-tech wet shoes by cutting holes in the toes of some old tennis shoes to let the water slurp out as he sloshes his way down the portage trail. Like his son, if he encounters a mud puddle along the way, he wastes no time or energy stepping around it. Even if it's more than ankle deep, he plows right through. He loves cutting and splitting wood, making shavings and starting the fire, and as I've noted, I love the way he gets up early in the morning and makes a pot of coffee, even though neither he nor Paul drinks coffee, preferring hot chocolate. Both father and son like to cook, and like me, they'll eat just about anything that doesn't eat them first, the one exception for Paul being peas, which unfortunately for him are a common ingredient in most freeze-dried food.

Paul likes helping out, something he is always doing for his children and his wife at home. Whenever my hands are full and I need a third hand, it seems that either he or his father appears with a friendly, "Let me help you with that." Although both are better at sitting still and relaxing than Dad, they won't sit if someone else is working. Paul loves talking about his experiences in Vietnam, and he loves doing things with his father.

Of the four of us, I spend the most time with my head in the clouds—sniffing the pine-scented air, reveling in the beauty of the natural world and listening for the sound of my paddle moving through the water or a loon working its magic across a still lake. For me, proximity to nature is a spiritual experience. Spending time in the Boundary Waters is like going to church. Like Bill and Paul, I love everything about being here. I enjoy every facet of camping and canoeing, not the least of which is the physical challenge, the exercise, the beauty, the wildlife, the smells, the sounds and the solitude. But most of all, I like spending time with people who are important to me. The Boundary Waters is where I have filled in the missing pieces from my childhood and where I have spent some time thinking about the kind of son and father I want to be.

When Bill Hansen greeted me at the beginning of our 1997 trip, he told me about his work with a federal mediation process initiated by U.S. senator Paul Wellstone. The goal was to resolve issues relating to three portages where motors were still being used to transport boats and equipment between lakes. There were hard feelings among local people dating back to a number of regulations imposed by the 1964 Wilderness Act, particularly those limiting access to the Boundary Waters and banning the use of motorized portages and motors in many lakes. The mediation process, which lasted nearly nine months, had concluded on April 28. Recommendations for reducing

airborne mercury pollution had been agreed upon, but no consensus had been reached on what to do about the portages and other core issues. Bill liked participating in the process, but he was disappointed by the lack of a decisive outcome.

"We were so close," he told me. "We lost an opportunity. If we had reached a broad community consensus on wilderness policy, it would have had a healing effect."

I was pleased to have Bill's son Paul back with us again this year. During our happy hour, he told us a funny story about his days in Vietnam. While stationed on Fire Hill 180, he and four other communications specialists built two radio huts for eavesdropping on the enemy. To make themselves more comfortable, they also built an outhouse, placing a ten-gallon drum beneath the hole. When a group of fifteen marines began using the facility, Paul's group told them they were welcome, but they had to help bury the shit when the drum was full. The marines, thinking the task beneath them, refused, so the communications specialists padlocked the door. A few nights later, the camp was rocked by an explosion. After that, both the specialists and the marines did without an outhouse.

The next day, we made it from Kawasachong to Polly by noon and camped at the west-facing campsite with the island just opposite, on the same site where Dad, Larry, Tim and I had camped in 1979 and where Dad, Bill and I had camped in 1995. I fished with Paul on the north end of the lake, where in 1988 I had learned from two guys in my men's group how to tie a lindy rig and where we had fished for smallmouth bass. No luck this time. It's funny how you assume that a hot spot will be hot every time you go back to it. It's a good theory. All it lacks are the fish.

We tried our luck again the next day on Hazel. Paul and I paddled out in the mist on an afternoon similar to the one Florence Page Jaques describes in *Canoe Country*:

> *I decided that fishing in the rain is far more glamorous than fishing in the sun, for the lake was gray moire, the mistiness changed from gray to soft Madonna blue, and the distant islands had dimmed to phantoms of faint violet. The rain made a tiny patting sound on the lily leaves and on our hats.*

Gray moire, Madonna blue and faint violet colors aside, Paul and I had a ball pulling them in. Paul caught a huge walleye, and I caught five, including

a three- or four-pounder (probably more like a seven-pounder), as well as a perch and a sucker. After a while, our arms grew weary from reeling them in, so we paddled over to explore the river upstream but found it tough going.

The next day, as we were traveling to Grace, I couldn't help but notice that our canoe was considerably faster than Bill and Paul's, although in fairness to them, they were using my friend Al's old beater, a bathtub in the water. Still, you tend to make better time when you go straight rather than zigzag across the lake.

The two campsites on the south end of Grace were occupied, so we paddled to the north end of the lake, where we found an exceptional site. After we made camp, I went out fishing with Paul and caught a four-pound bass, a real monster. Back at camp, I sat down to write in my log. Dad was lying on his air mattress nearby, commenting on how long the sun had stayed just on the edge of a long dark cloud. I told Dad I really appreciated his coming to Minneapolis for Eddy's high school graduation last June. It meant a lot to us. As we talked, he said something about "if I were to come canoeing again." I know our time together in the Boundary Waters won't last forever, but I don't like to think about it coming to an end.

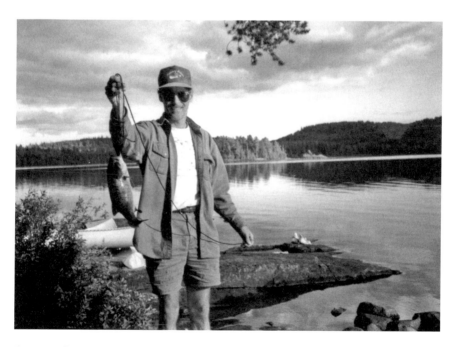

A monster bass.

Later, on an evening canoe ride, Bill and I paddled slowly around the island opposite our site as the sun was setting across the lake. I was glad Dad had Bill as a friend—good-natured, jovial Bill. This was Bill's eleventh trip. He would come for eleven more before calling it quits at age eighty-three. As Bill and I paddled and talked, the water absorbed the light from the darkening sky, as though it were soaking in its fading energy. Behind us, a full moon topped the darkening hills.

We've had our coldest weather ever, and our best fishing ever, on this trip. Dad caught three or four bass, Paul caught a huge walleye on Hazel and I caught a northern on Kawasachong, as well as five walleye, a perch and a sucker on Hazel and another walleye, a small bass and that monster bass (four pounds, probably more) on Grace.

Because of a fire ban—the area is nine inches behind on rain—we used a Coleman cookstove this year rather than cooking over an open fire. The stove makes cooking easier. Three to four quarts of fuel is sufficient for a week. I don't miss the sooty pots from cooking over an open fire, but I do miss the ambiance of a campfire at night and the chance to warm up and dry out.

On our last day, we camped at the high north-facing site just south of the portage on Alton. The view from the campsite was spectacular—dark clouds, patches of deep blue sky, sunlight sparkling on the waves, high hills on the horizon…and beyond? What? Not so long ago, it was the unknown—a vast continent of unbroken wilderness stretching west to the Pacific Ocean and north to Hudson Bay and the Arctic.

After pitching our tents and cutting some wood, we hiked an old trail that leads from our campsite here on Alton to the Sawbill Trail. It was so overgrown that it was hard to follow in places. The other guys wanted me to lead because I seemed to have a knack for spotting the trail. I was fascinated by the signs of how it once had been maintained, rocks lining parts of the path and the remains of fallen trees that had been cut out of the way maybe twenty or thirty years ago. It felt like hiking back in time.

When we came to the Sawbill Trail near the outfitters' building, we stopped. We didn't cross the gravel road. Without a word, we turned and headed back into the woods. The spell of the wilderness had been partly broken, and we wanted to avoid further damage.

Back at the campsite, Dad and I walked over to the north side of our peninsula to go for a swim out of the wind. I didn't realize it at the time, but the little clearing we found by the shore had once been a campsite but was now closed. Bill Hansen's older map shows two campsites in proximity on

Bill, Paul and Steve hiking the old Sawbill-Alton trail in 1997.

this peninsula: the one we were camped at and a north-facing one, where we were swimming. After we climbed out of the icy water and toweled off, Dad walked back to the campsite while I sat by myself on the rock, looking out at the lake. I sat there a long time, listening to the wind moving through the pines overhead, feeling clean and refreshed from my swim and thinking about my life—twenty years of canoeing with my father, twenty good years; Eddy about to leave home for college; Kate doing well in high school; my good fortune to be in love with a woman who loves me as much as I love her; the fine people in my life; my men's group; my other good friends. I felt blessed. Life was good. It wasn't always easy—even a good life isn't always easy—but it was good.

After dinner, Bill and Paul went at it again at the cribbage board. I love the way Paul gets excited when he wins and carries on when the old man beats him. Earlier in the trip, Dad and I played them as a team, but as sometimes happens, luck won over skill. Then Dad opened a love note Joan had tucked into his pocket before the trip. Romance at seventy-two. Imagine. Divorce is hard for everyone, even grown children, but it made me feel good to think Dad had found someone who made him so happy.

CLIMBING THE BRULE BOULDERS, THE FOURTH OF JULY STORM AND THE LONGEST DAY IN HISTORY

In 1998, our regular foursome put in on Sawbill and traveled to Cherokee and back, with day trips to Gordon and Brule. Dad really seemed to enjoy this trip, our twenty-first, more than I think he enjoyed our cold and rainy twentieth trip. There's a nice photo of him standing shirtless, his hand on a cedar tree, with the rocks and lake behind. I wonder if I'll still be paddling a canoe, hauling my gear over rough portage trails and sleeping on the ground when I'm seventy-three.

On South Temperance, we camped on the south shore hill. The birch trees there were already dropping their yellow leaves, and it felt—and smelled—like autumn. I wondered why the leaves had turned so early in the season. Was it because of drought? Then I remembered that two years earlier, some nearby hills had been scorched by a forest fire. It had come right up to the campsite and stopped (or had been stopped by firefighters). That afternoon we watched some distant thunderheads forming, and we braced ourselves for a big storm, but the clouds drifted past and it never rained. We took a day trip to Brule on a sunny day, climbed the boulder field and enjoyed the beautiful view. I like the way Dad labeled his photos with circles around Bill, Paul and me climbing the boulder field and with a note, "Steve on top." In the tent that night, I began reading Eric Sevareid's *Canoeing with the Cree*, a book about his daring adventure paddling with his friend Walter Port from Minneapolis to Hudson Bay in 1930, a trip of 2,250 miles. Sevareid was

Steve's dad at seventy-three.

A South Temperance campsite in 1998.

The red granite bluff on the west end of Brule Lake.

only seventeen when he made the trip. I marveled that someone so young could write so well.

The next year, 1999, was the year of the ferocious Fourth of July storm, the storm of a century. The online *Earth Bulletin* of the American Museum of Natural History describes "the terrifying spectacle" that struck the Boundary Waters on July 4, 1999:

> *A hot, muggy day turned dark, promising what at first looked like a standard-issue thunderstorm. Then the green clouds rolled in. The winds, having picked up considerably, abated briefly, then roared to life again with a ferocity unlike anything local residents or most park visitors had ever seen. Wind speeds as high as 150 kilometers per hour were recorded.*

As reported by Greg Breining in "Boundary Waters: The Fire Next Time," published in the *Minnesota Conservation Volunteer*, "The tall column of thunder heads expelled 'down bursts' that created straight-line winds, which gusted to more than 90 miles an hour. The storm left a trail of downed timber from

just northeast of Ely to the end of the Gunflint Trail, roughly 500,000 acres parallel to the international border."

Within thirty minutes, the storm downed about twenty-five million trees, cutting a thirty-mile swath across the Boundary Waters. Severely affected were approximately 367,000 acres, or 32 percent, of the Boundary Waters, 477,000 acres in northeastern Minnesota and 108,000 acres in Canada. The storm also damaged fifteen hundred of two thousand campsites and completely or partially blocked 550 portages. About twenty-five people were injured, some seriously. Miraculously, no one died.

According to the American Museum of Natural History's *Earth Bulletin*, "Several campers were injured by falling trees and some had to wait as long as a week to be rescued from remote campsites." Similar in strength to a tornado but much faster moving, the storm that did this damage was a derecho, or straight-line windstorm. The American Museum of Natural History offers this description:

> *The average derecho can cause damage along a storm front dozens of kilometers wide, and it races forward faster than a speeding train. (The Boundary Waters storm was clocked at 120 kilometers or 72 miles per hour.) Moreover, to be classified as a derecho, the winds have to affect an area at least 400 kilometers (240 miles) long, about the distance from New York to Boston. The storm that struck the Boundary Waters was several times larger than that. It developed over North Dakota, struck northern Minnesota, swept through Canada, and emerged in northern Maine a day later—a storm track at least 2,000 kilometers (1,200 miles) long.*

Both the ferocity and dimensions of this storm were unimaginable.

When our foursome arrived at the Sawbill Canoe Outfitters, Cindy told us about a neat route to the northeast of Brule that involved one long portage outside the Boundary Waters and then looped back near a former logging railway. The eastern end of this part of the Boundary Waters was a new area for us, so we decided to explore it.

We put in at Brule on a beautiful day, but it was windy, as it always seems to be on Brule. Unlike the year my Denver friend Larry canoed with us, however, the waves weren't so large that they prevented us from crossing to the north shore. I've had many enjoyable paddles in the Boundary Waters over the years, but paddling long, narrow Winchell Lake, with the wind on our backs and the rollers cresting and pushing us along, may have been the

most relaxing. The burned-out areas of the Misquah Hills, which we had seen in 1996, were still evident. On the portage to Gaskin, we hiked beneath cedars, birch and giant pines and then made camp on the west-facing campsite with a good swimming rock and a set of wooden steps leading up from the water, presumably installed to control erosion.

On the south side of Vista, we found an exceptional campsite with a spectacular view of the lake. After we pitched our tents, Paul and I paddled over to a nearby island, where we saw a jack pine that had been tipped over by the Fourth of July storm. We struggled to get it righted; then, as Paul held it, I propped it up with a dead branch. As we paddled back to our campsite, I turned to admire our handiwork. It was one insignificant jack pine, only about twenty feet tall, but I was pleased to think it might survive.

The next day, we saw signs of the Fourth of July Storm everywhere. On one portage, there were burned-out areas from lightning strikes every twenty or thirty yards. In places, entire stands of trees were laid over like matchsticks, all pointing the same direction. Trees were down on every campsite we passed, some having landed just next to tent sites. Seeing them, I marveled that no one had been killed.

Our travel day turned out to be the longest and hardest any of us has ever experienced on a canoe trip. The 190-rod portage from Misquah to Little Trout, with its steep hills, rocks and muck, was only the first of many challenges. When we took the mile-plus portage out of Ram and then down a gravel road that ran beside the stream, we were outside the Boundary Waters, an odd departure from our usual wilderness canoeing. Then, as we were loading the canoes at the mucky entrance to Bower Trout, Bill punched through some muskeg and sank up to his knee. He was stuck fast, and the harder he struggled, the deeper he sank. With Paul standing beside him and pulling him by his armpit, Bill tried to break the suction that was holding his leg. When he finally wrenched his foot free, it was minus a shoe and brown with slime. He reached down into the mucky hole up to his shoulder, felt around and pulled out a muddy glob, which he slipped onto his foot.

When we stopped for lunch on Bower Trout, we were tired but still feeling okay. We saw a vacant campsite but decided not to take it—a fateful decision. The next campsite we came across on Marshall was taken. By then, we were really tired.

As we paddled through Dugout and Skidway, we saw more signs of fire. We also saw the old railroad bed Cindy had told us about, although by now we were too fatigued to be interested. Finally, after ten hours of paddling

and portaging, we arrived on Swan. We were so tired that we could hardly lift our arms. Hoping desperately to find an open site so we wouldn't have to do yet another portage, we paddled toward the first campsite. It was taken. As we paddled across the lake, our progress seemed to slow with each stroke. Spotting the second campsite, we turned toward it, hoping not to see anything red, blue, orange or yellow that might be a tent or tarp or piece of equipment. To our great relief, it was open. Never has a campsite looked more beautiful and welcoming. That night, at Thank-God Campsite, I watched the moon rise above the lake, blissfully content with our beautiful surroundings.

The next day, our trip from Swan to Brule seemed relatively easy—even the 292-rod portage and climbing the mountain from Vernon to Brule wasn't so bad. We didn't like the look of the campsites on Brule Bay, so we stayed on the east campsite of a large island across from the portage.

After helping set up the tent and cut firewood, I went out fishing on the east side of the island and caught a nice trout. It was a good thing I caught it. We have a tradition of packing one dinner short on our trips with the idea that we have to catch fish for that dinner. If we don't catch, all we have to eat is a backup dinner of Kraft Macaroni and Cheese. Of course, the later in the trip we go without catching fish, the higher the odds we will have to go without a full meal. But tonight, our last night of the trip, we would eat well.

Later, Dad went out fishing with me. He had one but lost it. As he cast out his line, he told me he thought he had lost some power in his stroke.

"I don't know, Dad," I said. "You're still stronger than most people I've paddled with."

He cast his line out again and said, "I may not live another seven or eight years."

"You never know," I said. "You may live another twenty."

Then he asked me about the Boundary Waters book I had been talking about writing some day. "I think you should make it a history," he said. "Tell the stories behind the names of the lakes."

17

A Tumble, More Good Weather, a Broken Rod, Eddy's Return, a Bawling Moose, a Plethora of Smallmouth on Grace and a Waxing Moon

In 2000, we camped on Polly, revisited the pictographs on Fishdance and shot the rapids on the way to Alice. Dad, now seventy-five years old, seemed relaxed, jovial and healthy when I picked him up at the airport. At the outfitters, we learned that Cindy had broken her wrists earlier in the year when she took a fall while tap dancing.

"I had to do everything for her," Bill confided in me. "I mean *everything*."

On one of our portages, Dad stepped into a depression beside the trail and took a tumble. I was carrying the canoe behind him when I saw him fall. I heaved the canoe off my shoulders.

"Are you all right?" I said as I ran up to him.

He was lying on his back with one Duluth pack beneath him and a second one on his front side.

"I'm fine. I'm fine," he said, his head, arms and legs protruding like a turtle's from the pack on his belly. "But I can't get up."

I lifted the front pack from his belly and helped him up, relieved that the packs had cushioned his fall.

After a jovial happy hour, Bill and I canoed the lake at dusk, my favorite time to be on the water—the bewitching hour, when the mood of the fading light plays tricks between the water and the sky. The softest sound was amplified by the silence, and the least disturbance of the water's surface was magnified by concentric rings.

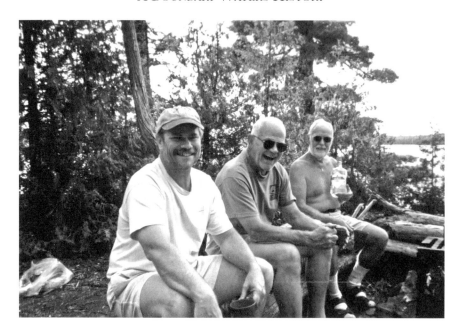

A jovial happy hour in 2000.

On our paddle from Polly to the island campsite on the Kawishiwi River, we had a clear, blue sky, not a breath of wind and water as smooth as glass. The campsite on the south end of the island, with its rocks and panoramic view, was exceptional. For our day trip, we paddled to the picture rock and then to Alice for lunch. We shot the second rapids to Alice without incident. I guess we hadn't learned our lesson.

I'll remember this trip as the year of the good weather. Six days of sunny, gorgeous weather. Monday was our only cloudy day. We had good fishing— caught a bunch of little walleyes on Polly and then a good-sized walleye and a northern on the Kawishiwi River for our Sunday night fish dinner, as scheduled. Dad was getting discouraged with fishing until he had three quick strikes on the east end of Malberg, finally landing a big northern.

At one point on the trip, I noticed that my telescoping fishing rod was broken just above the handle. It was the rod my friend Jim had given me. Bill said he may have broken it on a portage, but I thought it probably broke inside the pack the day before. It didn't matter. I repaired it using some unusual materials: a splint made from a smooth stick stripped of its bark, some duct tape and some twine Dad had found buried at his condo, probably from when the condo was built. I like the look and feel of my repaired rod.

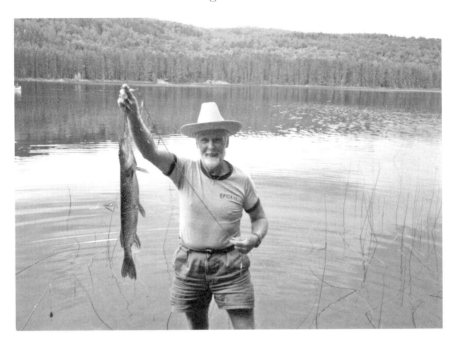

Steve's dad's big northern on Malberg Lake.

Steve's special handcrafted fishing pole.

I still have it today. When I canoe with my men's group, my friends call it "a piece of shit," and they wonder how I catch anything with it, but I do all right. I think they're envious.

In 2001, realizing that any year could be his grandpa's last canoe trip, Eddy came with us again. I had long awaited his return. He had last canoed when he was fifteen. He was now twenty-two. It was good to have not only him but also his friend Jonathan with us again. I remember watching them hike along a sandy beach on Frost when they were thirteen. Jonathan was more than a head taller than Eddy. Now, as adults, they're about the same height, a little under six feet.

Dad was afraid he would have to cancel this year. He had been suffering from cramps, stiffness and soreness in his groin and legs, and he didn't know the cause. As it turned out, his symptoms were side effects of Zocor, his cholesterol medication. At Joan's suggestion, he stopped taking his medication a week before the trip, and his stiffness largely cleared up, although he was still walking with a slight limp, so he cut a walking stick for himself at our cabin.

Our trip was sunny and warm, with cool evenings and mornings, and cloudy for only a few hours on our last day. We put in on Sawbill and paddled

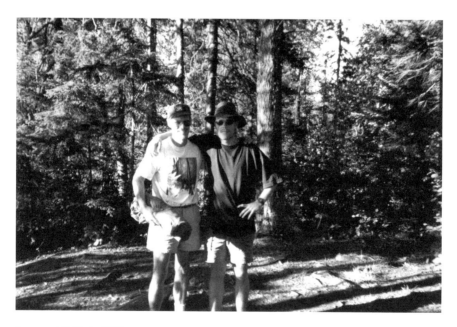

Steve and Eddy in 2001.

the Lady Chain from Beth to Hazel, camping on the way back on Phoebe, Grace and Alton.

On Grace, I went for an evening paddle with Bill and Paul. As an afterthought, I grabbed my vintage handcrafted "piece of shit" fishing rod, which happened to have a yellow plastic worm on the line, and I asked Bill and Paul if they would mind if I trolled while they paddled. No one expected what happened next. As we paddled through the reed beds by the portage leading south, I caught nine smallmouth bass, one after another. Each time I caught a fish, I threw it back; then we circled, and I caught another. Each time I hooked one, Bill and Paul hooted with laughter. We didn't quit until my yellow plastic worm had been worn to a stub by all the fishy gums chomping on it. What a treat!

On Alton, we liked our tucked-away campsite—one bay east of the southwestern bay leading to Perent Lake. It felt cozy and wild. When I paddled out later that afternoon, I came across six otters near a cedar leaning over the water. I watched them watching me, their heads poking up like periscopes. That night, our last night out, we were distracted by a noisy group of weekenders, singing loudly and carrying on. I considered paddling over and asking them to quiet down but decided against it. They weren't trying to be inconsiderate; they were just having fun, and they didn't realize how far voices carry across the water.

As always, I enjoyed the drive down the trail—the first stage of reentry—heading back toward the North Shore of Lake Superior. As soon as Dad could get a signal, he called Joan on his cellphone. I was struck by the love I heard in his voice as he talked to her.

One of the things I'll remember about this trip is the moon. Each night of our trip it grew a little larger, expanding from right to left, and each night it set a little later. Its progression made me think of my own life, how it has become fuller over the years, even as I, like my father, am beginning to slow down.

18

THE FOURSOME REASSEMBLED, CANOE TEAMWORK, PARTIAL FIRE BAN AND ONE LOST DAD ON THE BANADAD

In 2002, Dad, Bill, Paul and I did something different: we put in on Poplar Lake off the Gunflint Trail. As we drove up the North Shore, it was cold and foggy, but as we approached Grand Marais, the sky suddenly cleared and it turned sunny and warm. We had lunch at the Angry Trout Café, with our table on the deck overlooking the largest freshwater lake in the world, a "sweetwater sea," as Barton Sutter calls it.

We were concerned about the dry conditions. Bill Hansen told us there was a partial fire ban, meaning we were permitted to have fires only from seven in the evening until midnight. The northern third of Minnesota was experiencing an elevated fire danger due to a long-term lack of rainfall, below normal winter snowfall and later-than-normal green-up conditions. According to the spring 2002 issue of *Wilderness News*, the newsletter of the Quetico Superior Foundation, the dry conditions had delayed the "prescribed burns" planned for last spring. Those controlled burns, in which the forest is intentionally set on fire to mimic the natural cycles of nature, are intended to reduce the fuel load created by the millions of trees blown down in the 1999 windstorm. The higher the fuel load, the higher the probability of a major wildfire that burns so hot it destroys all the organic matter in the soil, including the seeds that would otherwise regenerate the forest. We were hoping we wouldn't have the major fire everyone has worried about since the blow-down.

We had an easy paddle to the eastern campsite of Caribou, but I was worried about Dad, who was now seventy-seven. He was wearing wrist braces because he was suffering from carpal tunnel pain. He also had pain in his rotator cuffs. At one point, he commented, "I have no business being on this trip." At our campsite, Dad had a tough time stringing up the rope to hang the food pack, but he seemed to enjoy figuring out a pulley system.

Our second day on Caribou was another warm, sunny one, so we set off on a day trip. First, we paddled to Horseshoe, where I caught a large northern while trolling. We took a long lunch break on the exceptional south campsite on Vista, the same site we stayed at three years ago when we had our marathon day traveling to Swan. I had a nice talk with Paul about his two daughters and his son. As we talked, Dad and Bill settled into a long conversation as well. It felt good to relax in this gorgeous setting, with the resonant voices of the older men in the background. After a while, Paul and I paddled to the rock-topped island where we had righted a tipped-over jack pine three years ago. I was pleased to see it had survived.

The next day, on Horseshoe, I untangled a knot in Dad's reel. When I got his line straightened out, he felt a tug and pulled in a small perch—his second cast. I was happy he was off to a good start fishing.

The first site on Gaskin coming from Horseshoe, a beauty, was taken. The next campsite, the one with the wooden steps, also was taken. We asked four young men paddling two canoes toward us where they had been, and they recommended the second-to-last campsite on the north shore. It also was a beauty, with a nice stand of mature white pines and an inviting gravel swimming area. "This is a nice trip," Dad said. On the campsite, he did something that seemed out of character. He made a floral arrangement of swamp blue asters and ferns and stuck it in a plastic bottle. I was surprised but pleased by his embellishment of our campsite.

There were no fish in Gaskin, but I had fun being out in the canoe with Dad. A beaver swam by within ten feet of the shore at our campsite, suddenly slapping its tail, which made me jump, and a loon hydroplaned past our campsite. We played doubles at cribbage, with Bill and me losing two out of three but later winning two out of three. One photo shows a game between Bill and Paul in process, with Paul scratching a mosquito bite and Dad working on his floral arrangement in the background.

Even though we took time to make an onion-and-cheese omelette with our extra eggs (we had brought eighteen this year rather than twelve), we were on the water by 8:00 a.m. The last portage to Meeds was tough. With a

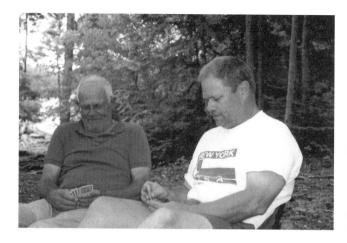

Left: Bill and Paul playing cribbage.

Below: More cribbage, with Steve's dad creating a floral arrangement.

tree blocking the path, I had to put down the canoe and slide it under. It was marked as a 110-rod portage on the Fisher map, but it seemed much longer.

As we were leaving the postage, I successfully sloosed Bill and Paul by tying a stick to their bow with some nearly invisible fishing line. Usually, they catch on right away, but this time I had the pleasure of watching them paddle away dragging the stick through the water behind them.

We arrived at Meeds by late morning. Two river otters greeted us at the portage. The island campsite on the east end of the lake was taken, but the

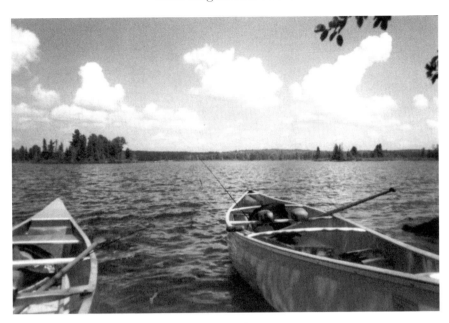

Old and new canoes.

campers were packing up their gear. A friendly guy offered to leave their leeches for us. As we were talking to him, an eagle swooped down and thrust its talons into the water but came up without a fish, a spectacular sight.

Although our island campsite was worn and open around the fire grate, it had a lovely view of the lake. Sunday morning was another beautiful day. I fished before breakfast and brought a small northern to the canoe, with an eagle watching my efforts from its treetop perch on the island. This was our last day, and we still had no fish for dinner. If we didn't catch, all we had was Kraft Macaroni and Cheese.

On a day trip to Caribou, we paddled a gorgeous, cattail-lined stream, saw a beaver dam and passed through a tunnel of trees. On our return trip, by the portage into Meeds, Dad caught a nice smallmouth bass. Then I caught another. Then I had a strike, and Dad caught a small northern, which we released. As we came around the western point of our island campsite, I caught a northern—we now had three keepers, enough for dinner! Once again, we were down to the wire.

Before dinner, we went for a swim, and then I paddled out on the lake. I looked back from the canoe at Dad, who was reading by the fire grate. Blending into the beauty around him, he seemed a long way from me, a

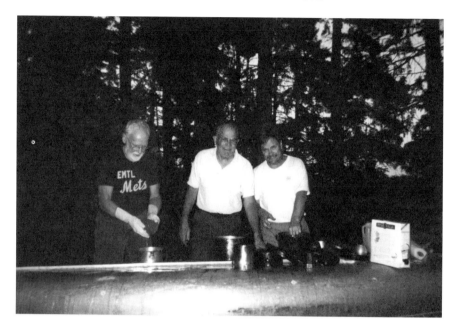

Steve's dad, Bill and Paul doing cleanup while Steve relaxes.

slightly stooped dot with two white pines towering above him. That night, as I climbed into my sleeping bag, I felt something smooth and cold at the bottom—a large rock. It was a gift from my friends in the other tent. Better let up on the sloosing.

The next morning, as we were walking the 320-rod portage back to Poplar, we came upon an opening in the trees where the Banadad Trail intersects. Some tall weeds partly obscured the portage trail, making it appear that the trail took a sharp left. When I doubled back for a second load, I passed Bill, who said, "Your dad has disappeared." For a while, we couldn't find him, and I began to worry. We soon learned he had turned left on the Banadad Trail, which takes its name from an Ojibwe word that means "lost." Fortunately, he realized his error and doubled back before he had gone too far.

On Poplar, we paddled out in a headwind. We worked hard until we rounded a point, and then, with the wind on our backs, we surfed with the waves. Despite Dad's aching hands, we had a nice ride in.

As he usually does, Dad said, "Good trip" at the end, but it was a hard one for him. It was our twenty-fifth annual canoe trip together, maybe our last. At Grandma's Restaurant in Duluth, as Dad was getting up to use the restroom, Bill made us laugh when he said, "Nice guy. But gets lost easily."

AN UNFORTUNATE ENDING TO A "GREAT AND GLORIOUS RUN"

O ur 2003 trip began on a beautiful, hot, sunny day. At the outfitters, we were impressed with the rebuilt and greatly expanded Sawbill Canoe Outfitters' building. Bill Hansen told us he was thinking about running for a seat in the Minnesota House of Representatives. As always, Cindy gave all of us a big hug.

On Brule, we managed the waves and camped on the north shore east of the Lily Lake portage. Steaks were great. Pudding was runny. Clouds blew in, and it poured.

The next day was clear, windy and cooler. We made it to our campsite on Winchell on the north shore, east of the bay, with the portage to Omega/ Ogema by noon, the same campsite where we had stayed with my friend Larry in 1996. We had the lake—at least our end of it—completely to ourselves. I enjoyed the exceptionally clear water, and again I was intrigued by the burned-over hillsides along the shore. Dad was feeling much better this year. He left his wrist braces in the car. He was still talking about future trips, and he seemed more enthusiastic about fishing this year. That night, we watched the stars and the northern lights, which were not spectacular but the best Paul has seen, as well as Mars, which was huge, as close to Earth as it has been in sixty thousand years.

The next day, after five hilly portages over the Laurentian Divide and long paddles into the wind across Whatever-the-Name-of-That-Lake-Is and

Kiskadinna, we were tuckered out by the time we reached Long Island. I got the chills and was feeling nauseous, maybe because I was dehydrated from the long paddle or maybe because I had a summer flu.

Despite not feeling well, I decided to go paddling on our "rest day." It started out sunny, but the wind kicked up, the clouds moved in, the temperature dropped and it began to drizzle. Somehow, we missed the passage to Karl near our campsite, so we paddled all the way up to the west bay. Dad caught a good-sized northern near the large pine with the eagle's nest, and we watched an immature bald eagle perched on a nearby limb. "That should go in the log," Dad said. So noted.

From there, we portaged and paddled to George and Ribb, where Dad and I both caught several small fish and one medium-sized northern, so we had our fish for dinner, only one day later than scheduled. We searched unsuccessfully for the old Dawkins Lake Trail, which is indicated on one of our maps but not on Bill Hansen's map. Dad cleaned the fish this year and did a nice job. In the evening, it cleared off, and it felt good to sit by the fire writing.

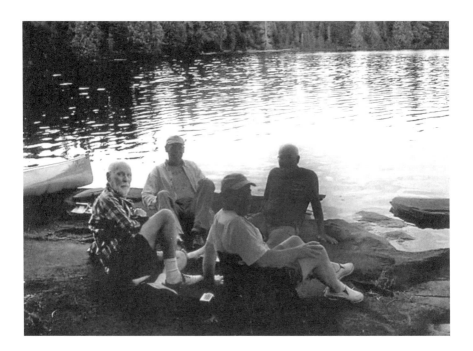

The foursome relaxing by the shore after dinner.

On past trips, Bill has always joked about how he spent his time serving in World War II playing golf, but this trip he told us something he had never talked about before.

"I also fought the Japs," he said.

"You did?" I said.

"Not only did he fight," said Paul, "but he received a Purple Heart for a bullet wound above his left eye."

"It just nicked me," Bill said. "I didn't really deserve it."

Then we talked about "a fluky accident" Bill Hansen had described on the Sawbill Canoe Outfitters' website, which Dad now visits daily, year round. In May, a camper fell while carrying a loaded canoe in the upright position on the portage from Sawbill to Alton. His hand was caught between the keel of the canoe and a rock, and he sliced off two fingertips. As Bill reported, "His friends picked up the severed pieces and rushed him back to the Sawbill store. Luckily, a Cook county deputy sheriff was visiting in the store and was able to rush the man to the hospital in his squad car." The fingertips were reattached, and he was expected to make a full recovery.

"Good thing they weren't farther out," Dad said.

Then Paul talked about retirement, which he thought was about five years away. He was eager. He bought a house that year for himself and one of his daughters. He's a grandfather now, and it's obvious that he loves his grandson.

As we were sitting by the fire talking, we heard something that caused us to halt our conversation. At first I thought it was a distant siren. Then there was another voice, and then others joined what became a yelping chorus, and I realized what we were hearing. It was a pack of wolves.

It's hard to believe that at one time there were programs to eliminate these animals and their hauntingly wild sound. Before the deliberate attempt by white settlers to exterminate them, their population was estimated to be between 4,000 and 8,000. During the 1950s, their population dropped to as low as 650 to 750 animals. As recently as 1965, a bounty was paid on wolves in Minnesota. Under that program, and the Minnesota Department of Conservation's control program, more than 300 wolves were killed annually. Perhaps because of the remoteness of the Boundary Waters, Minnesota is the only one of the forty-eight continuous states where wolves were never eliminated. In recent years, their numbers have increased and their range has expanded farther south. (As of 2011, there were about 3,200 wolves in Minnesota.) Now, thanks in part to the efforts of environmentalists like Aldo

Leopold, we've come to appreciate the role and rightful place of predators in the wilderness.

As suddenly as it began, the howling stopped. I howled to see if I could get them to start again. Instead of the response I was hoping for, a frog croaked nearby. I was offended. Paul thought it was hilarious.

"You're her prince," said Bill. "She wants a kiss."

The next morning, we paddled to Cherokee and stayed on the site where the bear ripped our food pack. After a happy hour that was a little happier than usual, Dad picked up a cooking pot and walked down to the shore to get some water for cleanup. Then we heard a splash.

"Was that what I think it was?" said Paul.

It was. Dad had fallen in. After we found out he wasn't hurt, we started laughing, with Paul literally falling to the ground. Dad took it well, but I didn't like seeing my father soaking wet, his T-shirt stuck to his skin and rolled up over his belly.

Later that evening, Dad was struggling to loop the food pack rope over a tree limb. After he finally managed to snag a limb, I told him I thought it was too low. Dad, who was already frustrated, dropped the rope end and walked away.

"Come on," I said to Paul. "Let's give it a go."

I pulled the rope down from the branch, and we started over. We struggled as Dad had, and in the end we didn't do much better. The rope was only marginally higher.

For the rest of the trip, Dad seemed unhappy with me. Except for a few strained exchanges, we hardly talked. On our last evening out, we camped on a site with towering red pines on the island north of the Brule entry point. Despite the beauty of the setting, Dad and I weren't having much fun. I hoped Bill and Paul were. After dinner, I paddled out by myself along the southern shore of the island. I caught a nice-sized smallmouth and released it. This wasn't the way I wanted our story to end.

FICKLE FISH, CANOEING WITHOUT DAD AND NO HAPPY HOUR

September 2003
Steve:
Here are this year's canoe trip pictures. Not as many as earlier years.
-a Kilpatric article
-an odd tree configuration on my walking trail
-two oil platform pictures that make me wonder how they can make money
-end of an era—I've decided that this year will be the last year for my houseboat (27) and canoe trips (26). It has been a great & glorious run with no regrets.
Dad

In 2004, we moved our regular late August trip to July and cut it one day short because I was having an especially busy summer presenting writing seminars. Unfortunately, at this earlier time of year we were finding more people and more bugs. Our put-in was crowded, with three groups setting off at the same time, and on Kawasachong, every campsite was taken, including one unofficial site that was occupied on the west shore. But there were advantages to coming this time of year. On our drive up the North Shore, I enjoyed seeing the cheerful plumes of lupine, and in the Boundary Waters, we heard the birds singing and saw fireweed, thistle and wild roses blooming, flowers we don't see in August. I was having fun, but I missed

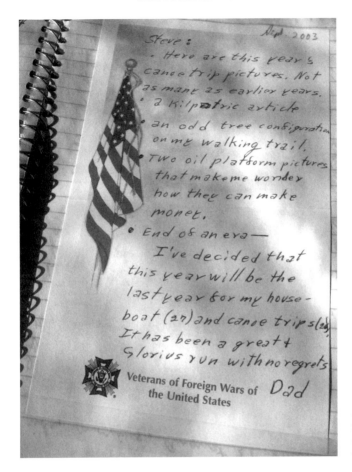

Steve's dad's 2003 note to Steve announcing "the end of an era."

having Dad along. I thought often of his words, especially when walking a portage or drifting across a still lake at night. It had indeed been a "great and glorious run," although for me there *were* regrets. I wished our "great and glorious run" hadn't been undercut by one bad experience at the end.

Taking Dad's place was my friend Tom, a member of my men's group and the inventor of the Boundary Waters Booster. He fit in nicely and even treated us to lunch at Grandma's. We made good time to Malberg, arriving on our campsite by noon, and we ended up staying there three nights, partly because the fishing was so good. On our first night, Paul and I each caught a northern; then I caught two nice smallmouth bass, and Tom caught three walleyes, so we had the first of two fish dinners.

On a day trip paddling the loop north of Malberg counter-clockwise, we saw a cow moose and twin calves in the south bay of the northeastern

A cow moose with twins on Malberg Lake in 2004.

arm. We stopped for lunch on the exceptional west-facing campsite on the Kawishiwi River north of the northeast arm where I had camped with Dad, Larry and Tim in 1979. We were delighted when three young otters ran right up to us, barking and scurrying about excitedly. Back on Malberg, we spotted a black bear on the far shore, west of the portage to Koma.

On July 24, Bill turned seventy-eight. We didn't remember it was his birthday until the next day, so we sang "Happy Birthday" to him then, with the three younger men hoping we would be able to continue canoeing as long as Bill had. That night, I paddled down the Louse River, following a rock channel that seemed mysterious in the nighttime shadows. Then, back at camp, I woke Paul to see some spectacular northern lights that were fluttering in curtains of flashing lights. The next day, our day trip down the Louse was beautiful, and the fishing was outstanding. In two hours on Boze, I caught fourteen fish, three along the way and then eleven good-sized walleyes. My friend Tom was using Rapalas, which walleye normally bite on, but he wasn't getting any action. I tried to persuade him to switch to spoons, which for some reason were working.

"No, thanks," he said quietly, his line arcing across the water. "I'll stay with what I'm using."

My luck continued, with Tom congratulating me a tad less enthusiastically with each fish I reeled in. Finally, I took his pole from him and handed him mine. "Here," I said. "Just try it." On our next casts, I caught a walleye with his rig, and he caught nothing with mine. We could only laugh.

We arrived at our campsite on Kawasachong by one o'clock that afternoon. The river between Square and Kawasachong was slow paddling where the water was low and the banks muddy. We enjoyed having the lake to ourselves on our last night out. As Bill, Paul and I set off for an evening paddle, I noticed Bill had trouble with his balance as he climbed into the middle position of the canoe.

The most memorable event of this year's trip was something that didn't happen: happy hour on our last night out. The night before, we had saved just enough gin for one more Boundary Waters Booster, as Tom calls them, or Boomer, as Dad calls them. After a long day of paddling, we were all looking forward to a treat. I'll never forget the look on Paul's face when he pulled the empty plastic gin bottle from the food pack and held it up for all to see. There were gasps and groans, followed by suspicious glances. Not a drop was left. It probably had leaked in transit—at least, that's the story we settled on. Paul lay down on a flat granite rock, either to ease the pain in his back or to console himself. The next day, we paddled out early.

CELLPHONE EMERGENCY CALLS, THE DISAPPEARANCE OF AN EXPERIENCED OUTDOORSMAN AND CHANGING TIMES

M y file contains three newspaper clippings from 2005. The first has to do with the dramatic increase in Boundary Waters emergency evacuations and search-and-rescue missions—this despite the fact that the number of deaths in the three preceding years remained fairly constant. According to Kris Reichenbach, a spokeswoman for the Forest Service, most deaths in the Boundary Waters are the result of drowning. The most common injuries are broken arms and legs from falling on rocks. As reported in the *Minneapolis Star Tribune*, there were four deaths in 2002, two in 2003, three in 2004 and one in 2005. The number of evacuations and calls, however, nearly doubled, from seventeen incidents in 2002, nineteen in 2003 and seventeen in 2004 to thirty-three in 2005. One possible explanation for the increase: more people are carrying cellphones, and despite spotty service, more of them are making calls. As a result, rather than handling emergencies on their own as they did in the past, more people are calling for help, sometimes without good reason.

"Being tired or running out of food is not good enough," said Reichenbach. "It needs to be a reasonable emergency."

The second clipping tells the story of Lloyd Skelton's disappearance. On June 4, Skelton, an experienced fifty-eight-year-old outdoorsman, got a day permit to hike the fourteen-mile Angleworm Trail. He had been planning to do a solo kayak trip but had decided to delay his trip until the cold, blustery

weather improved. On June 17, his daughter reported him missing. Searchers found only his clothing and wallet, and they assumed he had succumbed to hypothermia and "paradoxical undressing," an irrational behavior that sometimes occurs when a person's core body temperature drops into the low eighties. As reported by Larry Oakes, despite "a thorough search of the surrounding area with the help of dogs," no sign of his remains were found.

"It's tough to talk about," said Lake County sheriff Steve Peterson, a veteran of many searches, "but it's a reality that things don't last long out there. There is decomposition. There are wolves, bears, ravens. The longer it's been, the less the chance you'll find something."

A third clipping is about the largest Boundary Waters forest fire in ten years. It was in an area littered with dead trees from the 1999 blow-down. The numbers tell the story. On August 6, following a month of drought, lightning ignited a fire that swept across nearly fourteen hundred acres between Alpine and Seagull Lakes near the Canadian border, threatening seventy homes, cabins and businesses on the Gunflint Trail. Firefighters set up containment lines with thirty-five miles of hose, forty water pumps and more than one hundred sprinklers. With the assistance of three Bombardier CL-215 aircraft capable of scooping fourteen hundred gallons of water in eleven seconds, they contained the fire on August 19.

We put in on August 5, 2005, the day before the big Alpine Lake fire started, but we saw no signs of it during our trip. We rented a one-person Prism from Bill Hansen so that the three of us wouldn't be crowded in a single canoe. I enjoyed my time with Bill and Paul, as I always do, but I missed Dad again this year. The trip felt incomplete without him. I didn't keep my log or even jot down any notes.

I do have some vivid, mostly pleasant memories of the trip. I remember the tough portages over the rocks on the way to Cherokee; the beautiful sunny days on Frost, with its boulder rising improbably from the shallow northeast part of the lake; a friendly group of women who joked with us about joining us for happy hour; and a day exploring the islands and bays of Long Island Lake. And then there was the oversized church group that crowded us on the portages between Cherokee and Sawbill. They were actually two groups of about twenty people that had combined into one, a practice that is against the rules (like bringing cans into the Boundary Waters). A BWCAW management plan implemented in 1994 limited the number of watercraft per group to four and reduced the maximum visitor-group size from ten to nine persons. As we carried our gear down what felt

like a crowded sidewalk, waiting and stepping aside for our fellow travelers, I was reminded of the reason for those limits.

The best part of my trip was the e-mail message I received from Dad a few weeks after I got home:

> *steve*
> *if my back continues to improve, the BWCA is not out of the question in 2006.*
> *dad*

22
DAD AND EDDY ONCE AGAIN, THE CAVITY LAKE FIRE AND ONE PATHETIC BEAR

As we put in on Kawishiwi Lake in 2006, the second large Boundary Waters fire in two years, the Cavity Lake fire, was nearly contained but still burning. After being ignited by a lightning strike one month earlier, on July 14, it had expanded north to Sea Gull Lake near the end of the Gunflint Trail. It was one of eight or more fires burning in the Boundary Waters and Quetico Park during the week of our trip, all started by lightning. Fueled by dry winds and timber blown down in the 1999 storm, the Cavity Lake fire burned about fifty square miles (or about thirty-nine square miles excluding lake surfaces), an area that made it the largest fire in the Boundary Waters since 1894. About sixty campsites in the fire area were damaged or destroyed, but fortunately no one was injured, and there was no damage to private property. Smoke blowing east from fire was so thick that motorists on the North Shore had to turn on their headlights during the day.

It could have been worse. A series of prescribed burns since the 1999 storm had reduced the amount of downed timber on more than thirty-seven thousand acres, preventing the fire from consuming an even larger area.

"It's a good thing this fire happened when it did," said Jim Sanders, supervisor of the Superior National Forest, "instead of two years after the blow-down."

Although no evacuation of the Gunflint Trail was ordered, the fire's eastern flank came within a mile of the trail, close to the trigger point for

an evacuation. As the fire continued to expand, an elite team of firefighters known as the Pacific Northwest National Incident Team No. 2, one of seventeen such teams in the country, was dispatched. By August 4, the fire was reduced to hot spots and declared 85 percent contained. By August 12, five days before we began our trip, the fire was declared 95 percent contained, and according to Warren Wolfe writing for the *Minneapolis Star Tribune*, there already were signs the forest was rejuvenating: "Small sprigs of grass, ferns, and geraniums already are pushing through blackened soil, and tiny shoots of aspen and birch are emerging from charred stumps and roots." The cost of fighting the fire to that point was estimated at more than $10.6 million.

Then, a few weeks after our trip, on September 15, about two hundred people evacuated a ten-mile stretch of the Gunflint Trail at the "strong suggestion" of Cook County sheriff Mark Falk because a long, narrow finger of another fire was moving northward toward the dead-end trail. Like the Cavity Lake fire, this one was started by a lightning strike, this time near Famine Lake, north of Brule, on September 7 or 8. A smaller fire at Redeye Lake started around the same time. It was the fire's location rather than its four-square-mile size that prompted the voluntary evacuation, the first evacuation since the mid-1990s. The Famine Lake fire eventually consumed more than six and a half square miles.

Despite all the excitement from fighting fires and worrying about their spread to property outside the Boundary Waters, we had a peaceful, enjoyable trip, with both Dad and Eddy back again. Given the way our 2003 trip had ended, I began our trip determined to make this trip a good one for Dad.

On Hazel, we explored the channel and stream leading out of the lake, as was our custom. Using a stick to keep his balance, Dad followed cautiously along. He ventured as far as the deeper chasm and then turned around and slowly made his way back to the portage trail while the rest of our group, including Bill, clambered down the rocks. As I watched Dad make his way along the rocky streambed, I felt saddened by the thought that my once all-powerful father was physically diminished. But I also felt happy that at eighty-one he was able to be part of a group of guys bumming around on a warm sunny day in the wilderness. Life is so long but also so short. How many more years does he have on this earth? How many do I have?

The long portage to Beth was hard on Dad, and he was more than ready to climb out of the canoe when we arrived at our campsite at Alton. As we were eating our lunch of peanut butter and jelly sandwiches at the lower

part of the campsite, where we had pitched our tents, a very large black bear appeared and walked boldly toward us, holding its left forepaw off the ground as it limped along. I ran him off and then realized—nearly too late— that he would circle around and head for the upper part of the campsite, where we had left our food pack on the ground. That's exactly what he did. I dashed up the trail and arrived just in time to run him off a second time. As I yelled and waved my arms, he turned his head from the food pack and faced me, a line of saliva dangling from his mouth, then began walking reluctantly away, as bears do, as though to say, "All right, I'll leave, but don't think for a moment I'm afraid of you." I grabbed a good-sized stone and cocked my arm. I had a clear shot at his rear end, but not having the heart to hit a limping bear, I altered my aim just as I let go. The stone skipped across the dirt behind him, and he gave a little hop and increased his speed, but only by a little.

After dinner, I took one of those long, relaxing paddles with Bill that I love taking. We paddled up to the north end of Alton, a good distance, and admired the spectacular view of the lake from the elevated campsite there.

A moment before a limping bear went after the food pack.

Another site worth returning to. Later, just as the sun was setting, I paddled to the east shore north of the bay with the big white pine and rock face that marks the portage to Sawbill. I pulled the canoe up on a tiny rock island, stretched out under a tree and watched the sun drop behind the tree line above our campsite, feeling satisfied—and relieved—that I had had one more good trip with my father and my son.

Fortunately, the bear did not return. Back at the outfitters, the Sawbill crew members joked about how it wasn't really injured. It just held up its paw for sympathy, affecting a limp so that campers would feed it. Smart bear!

Anger Run Amok, the Ham Lake Fire, Kate and Markus, Simmering Heat and a Blazing Finish to a "Great and Glorious Run"

Two Boundary Waters calamities—one man made, one natural and both extraordinary in their ferocity—marked the summer of 2007.

In a scene of harassment reminiscent of the movie *Deliverance*, the first calamity occurred on August 7, 2007, when five local men and one sixteen-year-old juvenile went on a rampage on Basswood Lake, terrorizing and harassing dozens of campers, including families with children. They shot a flare that exploded in the air, released gasoline onto the lake and set it on fire and occupied one campsite for forty-five minutes, threatening to kill the three traumatized campers—a retired schoolteacher from suburban Chicago, his twenty-six-year-old daughter (whom they threatened to rape) and his eleven-year-old son, all of whom hid in the brush during the ordeal. During the spree, the men reportedly shouted, "Fucking tourists…get the hell off our fucking property" and—using the local slang word "enox" for "environmentally obnoxious people—"Go home, fucking enox tree-huggers." Some of the terrified campers used their cellphones to call 911 to report the disturbance, and within an hour, the five men and the teenager were arrested not far from the lake. From their two boats, authorities recovered a high-powered, semiautomatic assault-style rifle with three thirty-round clips, a .45-caliber semiautomatic pistol, a .22-caliber rifle, a .22-caliber pistol, ammunition, spent shell casings, fireworks residue, beer and items stolen from one campsite.

Newsweek and other publications linked the night of terror by the "Ely Six" to deep-seated resentment on the part of local people who opposed the 1978 restrictions limiting their access to the area, some of whom had been forced to sell their resorts and cabins. But as news of the disturbance spread, people who lived both near and far away, even those who resented the regulations, were aghast. An editorial in the *Timberjay*, a local community newspaper, conveyed their sentiment:

> *While there has long been a tendency in our area to paint youthful rebels who run afoul of the Boundary Waters regulations as folk heroes, this is a different situation entirely...This wasn't...like motoring in a paddle-only lake, or a late-night border run on a snowmobile...This isn't folk hero material. Such actions should horrify everyone.*

People surmised that because five of the six members of the group were not yet born when the area was set aside, their behavior reflected lingering anger and resentment over the laws and methods used to set aside and protect the wilderness. "They learned these attitudes," said local outfitter Nancy Piragis. Lake County authorities filed seventy-nine charges against the six, including terroristic threats, aggravated harassment, criminal damage to property, reckless discharge of firearms, underage possession of firearms and underage alcohol consumption.

A second calamity, this one natural, occurred earlier in the summer. On May 5, 2007, following a prolonged drought, a fire started near Ham Lake, apparently from an unattended campfire. Before it was extinguished, it became Minnesota's largest and costliest forest fire since the 1918 Cloquet fire.

On May 6, a mandatory evacuation order was issued to about one hundred people on the last seven miles of the Gunflint Trail as the rapidly spreading fire was fueled by strong winds. As with the Alpine Lake fire in 2005 and the Cavity Lake fire in 2006, the fire's intensity was at first limited. Prescribed burns had reduced the fuel load of downed trees on the fire's eastern flank. Four structures near Sea Gull Lake were destroyed, but many buildings were spared, probably because propane-powered outdoor sprinkler systems had been installed since the 1999 blow-down. On May 9, firefighters conducted an intentional "burnout" in the fire's path to rob it of fuel. On May 10, Twin Cities residents could smell smoke carried by northeastern winds. In parts of northern Minnesota, the entire sky was red. By May 11, the fire had grown to fifty-five thousand acres, or nearly eighty-six square miles, and it

had moved thirteen miles into Canada and twelve miles down the Gunflint Trail, destroying 138 structures worth $3.7 million, including the Seagull Outpost Lodge, Superior North Canoe Outfitters, 44 structures in the fifty-one-year-old Wilderness Canoe Base on Sea Gull Lake and 62 cabins and homes. According to Matt McKinney, writing for the *Minneapolis Star Tribune*, residents who saw the blaze described it as "a roiling black monster throwing off green clouds, white thunderheads and a noise like a freight train."

By May 15, the fire had consumed 93 square miles or 59,611 acres of forest and was only 15 percent contained. On the U.S. side of the border, seven hundred firefighters battled the blaze, some climbing atop buildings and dousing them with fire hoses as their own cabins burned. Finally, on May 22, after consuming nearly 119 square miles in Minnesota and Canada, the fire was contained, and the last 7 miles of the Gunflint Trail were reopened.

Although the fire danger remained, in September and October, a near-record rainfall ended a nearly two-year drought in the border lakes region. As reported by the Associated Press, "The Forest Service is more than halfway toward its goal of purposely burning 109 square miles to create a strategic series of firebreaks across the blowdown area." Even so, according to Jim Sanders, supervisor of the Superior National Forest, the danger was expected to remain elevated through 2017 or longer because of all the dead timber that remains, especially in the western parts of the forest closer to Ely, an area that had been mostly spared of fires. According to Cook County sheriff Mark Falk, "The Ham Lake fire wasn't the big blow-down fire we've been talking about for so many years. That's still out there, still a possibility."

In contrast to the violence and drama of these events, my story of canoeing with my father ended peacefully and quietly in 2007, the way Boundary Waters stories are supposed to end, the way most do. When I sent a note to Bill Bower, my editor at the *Fort Worth Star Telegram*, informing him I would be taking two weeks off from writing my weekly newspaper column to go canoeing in the Boundary Waters, he wrote back jokingly, "Enjoy your trip on the…what are the Boundary Waters? Is it that dotted line across Lake Superior?"

So once again, I was in the Boundary Waters Canoe Area Wilderness, this extraordinary place layered with history, danger and adventure, this "precious and picturesque" landscape that has provided me with so many wonderful experiences and memories. Because my daughter was getting married in August, we moved our trip to July to avoid a conflict with her and Markus's wedding. Unfortunately, the earlier date prevented Bill and

Paul from joining us on what would turn out to be Dad's last trip, but Kate and Markus came. There are many things I like about Markus, but perhaps what I like most is his love of camping—that and his talking Kate into going canoeing with me again, even if they could be here for only part of the trip.

As I sit here writing in my log, I hear the loons calling, and now the song of the white-throated sparrow—a gentle refrain, Old Sam Peabody-Peabody-Peabody repeated over and over again. Both songs punctuate the vastness of this wild space. We're camped on the west end of Alton. From time to time, voices drift across the water from a group playing on the jumping rock. The sound of children's laughter floats across the water. Everyone except me is napping—Kate and Markus in their new Hubba Hubba tent Debbie and I gave them for Christmas, Dad resting his back in my old Timberline tent. He's only a little sore, he says, and is mostly free from aches and pains. He seems to be moving better than he did last year. He's been telling people this year will be his last trip, and both Eddy and Bill Hansen told him, "You've said that before."

Everyone is relaxed and working well together. Earlier, my daughter—soon to be married, so beautiful with her hair braided back over her head, the way Debbie used to fix it when Kate was a little girl—was sitting by the shore, her head leaning against Markus's shoulder.

Later, Kate and Markus went fishing with me in the bay where I had seen the otters on our 2001 trip. We didn't see any this year, but it was fun paddling up the wild-looking stream with Markus diving for my snagged jig, somehow exiting the canoe and clambering back in without capsizing us, and Kate teasing us by saying, "You said this was fishing. I don't see any fish." Paddling slowly back to camp, we saw a spectacular sunset creating a crimson rim on some small gray clouds, then the sliver of a crescent moon and Venus glowing near the horizon.

We've been sharing lots of stories about Bill and Paul: "Coffee's ready." Bill mixing different-flavored oatmeal envelopes together. Paul exclaiming about his father's luck in cards—"You got hit again in the belly button! You always get hit!"

At the cabin, Dad had talked to me about things he missed out on growing up. There were only 120 kids in his Covington Catholic High School. They didn't even have their own building. The basketball court was in a basement, with a ceiling only four feet above the basket, so they were always hitting the ceiling when they were shooting.

"I would have loved to have been in choir," he said.

I didn't know that. How many other things about my father do I not know? How many things will I never know?

"One thing I've always regretted is never learning to play an instrument," he said.

Didn't know that either. Although my sister Linda and I were the ones who showed the most interest, all five of Dad's children were given music lessons. I wonder if it made Dad feel happy or sad to hear me practice the accordion, the bass fiddle and the piano.

Driving up the North Shore with Dad, we talked about family, about my sister Lisa and her husband, Bill, and about their special-needs son, Billy. We talked about my sister Linda's real estate business being slow this year and my brother Larry making progress remodeling his home. Now I'm thinking about the things Dad does: how he never resets his watch when he travels to a different time zone, a habit that in 1971 made me wonder why some friends were late in arriving for my graduation from Vanderbilt. His way of taking a handful of peanuts and giving them a shake before popping them into his mouth. His corny jokes about being an engineer. ("I can't spell 'engineer.' I are one.") Our lives are made up of so many insignificant details and events, but memories of some of the most trivial things come to me now like pinpricks of good feelings.

As always, it was good to see Bill Hansen at the outfitters. He said they had been busy tearing down the shower house and sauna to make room for an addition that would house their combined heat and power system. He seemed tired as we talked, and he said you have to make concessions to getting older.

Dad is up from his nap now, the back of his T-shirt stained crimson from his red knapsack. A family in a canoe paddles by our campsite. Two—no, three—children in the middle. I wave, but they don't see me. A young girl's voice, innocent and sweet, drifts across the water.

On the way up, as we were bouncing over the washboard gravel of the Sawbill Trail, Dad told me he was proud of me, proud of all his children.

"In every way," he said. "Values, career-wise, as parents."

I think he was making a point of saying things he had always meant to say to me but never had. He also said he hoped Eddy would figure out what he wanted to do next. It's natural, I guess. The old generation worries about the new. Young and old, we have our dreams. So many dreams, so many unrealized. Dreams for our children and for ourselves.

We're camped on Beth, on the site by the portage and the jumping rock. We've had another gorgeous day, slightly warmer this morning. Last night,

there was a bloodbath after I entered the tent and discovered dozens of mosquitoes clinging to the roof. They had been feeding on Dad, and every one was engorged with his blood. With each clap of my hands, my palms grew redder and redder.

This morning, Dad and I went fishing. We caught seven smallmouth each. Dad said it was the best he had ever done. Seeing him so pleased made me happy. The smaller smallies kept robbing us, and with so much action, it was a lot of work keeping minnows on our hooks. It's hard for Dad to turn around and reach the minnow bucket, so I baited his line for him. As I did, I thought about how he once put worms on my hook when he took my brothers and me fishing at Winton Woods. I remember our bamboo poles and little wooden bobbers with their white and red horizontal stripes.

Kate and Markus said they'd rather just hang out here on Beth instead of day tripping over to Grace today, so we did. Now the plan is to paddle across the lake and have lunch on one of the west campsites. Last night, we paddled over to the jumping cliff. Everyone except Dad jumped off the cliff several times, and then we sat watching the sun make its way toward the horizon. It felt good to settle back on the bare granite rock, still warm from the heat of the sun, as the evening breeze cooled us. Looking down the length of the lake with the beauty of the Boundary Waters before us, I watched Dad climb into one of the canoes and slowly paddle back to the campsite, his profile and tall straw-hat silhouetted against the sparkling water, the bow of the canoe angled sharply upward toward the sky. It was a picture I'll never forget.

Yesterday, we were comparing Beth to Hazel. Dad said the reason he liked Hazel better was that the first time we stayed there we had found so much cut and split wood waiting for us on the campsite. Didn't know that.

The breeze is picking up as I sit here. There it is, along with that gentle rustle of the pines. A symphony. This morning, while Dad and I fished and Markus pumped lake water through his filter for drinking, Kate cooked breakfast. Blueberry pancakes and sausage, a real treat.

Dad's hearing is not as good as it used to be. He misses a good part of the conversation. I raised my voice and asked him how his back was doing, if he was feeling any pain, and he said, "Well, it's a back." Earlier, we were trying to remember how many feet there are in a mile, and without hesitating, Dad said, "5,280."

"I'll miss having an engineer along on these trips," I told him.

As we left Beth and headed toward Sawbill, I realized I was taking what would surely be my last portage with Dad from Alton to Sawbill. Dad and I

said goodbye to Kate and the man she would soon marry. Then we watched them paddle toward the Sawbill canoe landing. Turning our canoe, we headed north on Sawbill in search of a campsite for our last two nights out. We found a vacant site on the bay that leads to Kelso. According to the 1995 entry in my log, both sites in this bay were good ones. As we were making camp on the southern one, I enjoyed pitching a tent with Dad, savoring every part of the process, taking satisfaction in the simple pleasure of erecting a temporary shelter for the night.

It was Dad who suggested we go fishing. With the weather vacillating between clouds and hints of sun and then clearing to deep blue sky, we took a slow drift up the bay. We each caught a few fish and released them. They came in two sizes: small and smaller. Then I caught a nice-sized walleye, which we cooked to perfection, if I do say so myself.

And now the loons are chorusing somewhere south of us, maybe on Sawbill, maybe on another lake, their rich, luxurious voices a blessing and affirmation of our existence. I'm so pleased Kate and Markus were able to come for Dad's final trip, but I'm also enjoying this time alone with him. Dad talked again about my brother Larry's efforts to have his house ready for his daughter Nellie's graduation party and about Lisa's relief that things were going well for Billy in his new home. And once again he told me he was proud of me, proud of all his children. It was the most Dad has ever talked to me about our family. Later, the zipper of his sleeping bag got caught, and I helped him zip it up.

Mosquitoes are awful tonight, but I don't care. I'm sitting beside the dying fire in my red nylon jacket with a towel draped over my head and the Big Dipper hovering above. I want to write, to capture some last details of our trip. Like Dad's snoring waking Markus on our first night out, and Markus declaring loudly, "That was a bear!" Like gliding along with the wind on our backs this morning with Kate and Markus nearby, together the two canoes riding the gentle waves. Then, today, that sweet feel to the air when it finally cleared. Dad and I both noticed it.

Dad is rustling in the tent. I hear the zipper. He's out for a pee, something he has to do two or three times a night these days. These last few trips have been hard for him.

What else? Tonight we talked about Eddy again. Then we talked about my grandmother Mawmaw, who was a genius with numbers and who died wealthy, the first woman in northern Kentucky to own her own real estate and construction business, Field's Realty. Dad told me about her two brothers,

both bright men, one an entrepreneur and the other a waiter all his life. As we talked, my eyes rested on a young jack pine. Such soft green tips, so different from the weathered, scraggly adult tree. And now I've arrived at my last blank page in my blue spiral notebook. I think I'll save that page for tomorrow.

When I close my eyes, the years fall away like shooting stars. I see our tent in the moonlight. Dad is sitting on the edge of my bed singing "Old Man River" to my brothers and me. I hear Sig's resonant voice. He's reading from *The Singing Wilderness*, words he worked on for so many years. Writing didn't come easily for him. It was a labor of love, in equal parts. "Because the river ran north and south at that point," he says, "the moon shone down the length of a long, silver pool, turning the rapids at its base into a million dancing pinpoints." I see myself settling down on a cushion of moss beneath one of those gray-barked cedar trees that line the shore. I grow drowsy with the smell of pines and water. At my feet, the waves chuckle against the rocks. My daughter takes my hand and tells me not to forget. Don't lose those memories, she says. Lay your hand on that boulder. Listen to those rapids. Can you hear the wolves howling? Have you ever paddled across still water in the early morning sun with your life opening before you? Do you see how your wake makes two diagonal lines across the lake behind you, how those lines move along the shore at the same pace you're paddling? They form a giant V with you at the apex, pinpointing with GPS accuracy your present location for any passing bird or wandering creature to see. Has the moon ever made a path across the water for you? Have you found yourself amongst the stars one midsummer night? "When you have descended into dreams," Paul Gruchow writes, "when your body functions according to its preconscious will, as it has operated through all the millennia of humankind, when you have abandoned yourself fearlessly, automatically, to whatever the night and the forest might bring—" What? What then?

Monday, July 23, 2007. West Sawbill Bay, southern campsite, across from the Kelso portage. Day trip to Kelso. Osprey overhead, fish leaping for my minnow, a boulder (a glacial erratic) posed on the west bank of the channel, on the verge of rolling into the lake. Again, Dad fished eagerly. He took his time trolling, paddling slowly. He caught two small northern in quick succession, eleven fish for the trip, his most ever. The Kelso River is wild and beautiful, lined by water lilies and reeds and fields of tall grasses, my favorite kind of paddling. This loop would make an excellent short trip. We could camp on the south campsite, the one on a high rock with a panoramic view of the lake, where Dad and I lunched and swam and cooled off in the ninety-

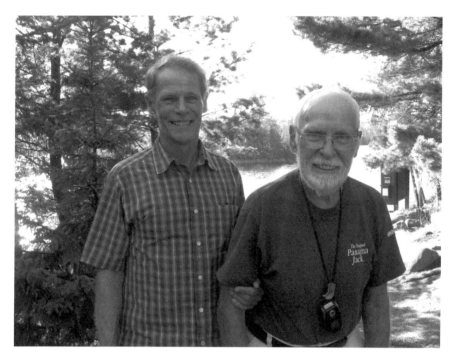

Steve and his dad revisiting the Sawbill landing in 2010.

degree heat. We sat there and talked about twenty-nine years of canoeing together, marveled at how the years had gone by. I told Dad I thought he and I had had some of our best times together as adults in the Boundary Waters. I'm glad I took this opportunity to tell him. I think it often.

Now I'm sitting in the shade of a clump of cedar trees, looking out over the little bay south of our campsite. I notice a small round hole in the rock next to my foot. I wonder how it got there. It's an inch around and a few inches deep. It was drilled years ago, I'm guessing, maybe for a sign or a fire grate. There's no breeze. The afternoon is still—quiet, muggy. On the hill above me, near the fire grate, Dad is sitting in his blue and white camp seat with the aluminum frame. He's snoozing, his head fallen forward, his tall straw-hat tilted down over his forehead. Someday he'll be gone. But he's here with me now.

Sources

Backes, David. *The Life of Sigurd F. Olson: A Wilderness Within*. Minneapolis: University of Minnesota Press, 1997.

Breining, Greg, and Jerry Stebbins. *Boundary Waters*. Minneapolis, MN: Nodin Press, 1983.

Breining, Greg, and Layne Kennedy. *Paddle North: Canoeing the Boundary Waters–Quetico Wilderness*. St. Paul: Minnesota Historical Society Press, 2010.

Carson, Rachel. *Silent Spring*. Boston: Houghton Mifflin, 1962.

Crowley, Kate, and Mike Link. *Boundary Waters Canoe Area Wilderness*. Stillwater, MN: Voyageur Press, 1987.

Downes, P.G. *Sleeping Island*. New York: Coward-McCann, 1943.

Furtman, Michael. *Magic on the Rocks: Canoe Country Pictographs*. Duluth, MN: Birch Portage Press; distributed by Adventure Publications, 2000.

Gruchow, Paul. *Boundary Waters: The Grace of the Wild*. Minneapolis, MN: Milkweed Editions; distributed by Publishers Group West, 1997.

Heinselman, Miron. *The Boundary Waters Wilderness Ecosystem*. Minneapolis: University of Minnesota Press, 1996.

Henricksson, John. *North Writers: A Strong Woods Collection*. Minneapolis: University of Minnesota Press, 1991.

Jaques, Florence Page. *Canoe Country*. Minneapolis: University of Minnesota Press, 1938; 1999.

Lund, Duane. *Our Historic Boundary Waters*. Staples, MN: Nordell Graphic Communications, 1980.

Magie, Bill. *A Wonderful Country: The Quetico-Superior Stories of Bill Magie*. Edited by Dave Olesen. Sig Olson Environmental Institute, 1984. Reprint, Ely, MN: Raven Productions, 2005.

Olson, Sigurd. *Listening Point*. New York: Knopf, 1958. Reprint, Minneapolis: University of Minnesota Press, 1997.

Paddock, Joe. *Keeper of the Wild: The Life of Ernest Oberholtzer*. St. Paul: Minnesota Historical Society Press, 2001.

Rutstrum, Calvin. *Once Upon a Wilderness*. New York: Macmillan, 1973.

Searle, R. Newell. *Saving Quetico-Superior: A Land Set Apart*. St. Paul: Minnesota Historical Society Press, 1977.

Sevareid, Eric. *Canoeing with the Cree*. New York: Macmillan, 1935. Reprint, St. Paul, MN: Borealis Books, 2004.

Sutter, Barton. *Cold Comfort: Life at the Top of the Map*. Minneapolis: University of Minnesota Press, 1998.

Wood, Douglas. "In a Small World." *Canoe Magazine* (July 1989).

WEBSITES

BWCA Glossary. www.rook.org/earl/bwca/lists/glossary.

Oberholtzer Timeline. eober.org/Oberholtzer/Timeline.shtml.

"The Ojibway Story." Turtle Island Productions. www.turtle-island.com/native/the-ojibway-story.html.

Wilbers, Stephen. "Boundary Waters Chronology." www.wilbers.com/BoundaryWatersCanoeAreaWildernessChronologyWelcome.htm

INDEX